THE 1990s FASHION BOOK

DIE MODE DER 1990ER-JAHRE

PIERRE TOROMANOFF

THE 1990s FASHION BOOK

DIE MODE DER 1990ER-JAHRE

teNeues

| 010 | **INTRODUCTION:** **A DECADE OF HOPE AND ANXIETY** |

| 014 | **CHAPTER 1:** **FIVE FASHION STYLES THAT DEFINE FASHION OF THE 1990s** |

016	Grunge
024	Hip-hop and the rise of athleisure
036	Minimalism
048	Deconstruction
058	Casual chic and preppy style

| 066 | Cult hairstyles of the 1990s |

| 078 | **CHAPTER 2:** **FASHION STARS OF THE 1990s** |

080	A new generation of fashion designers
098	The rise of supermodels and fashion photographers
112	Fashion in cult series and movies
120	In the beginning there was MTV

126 A fashion icon of the 1990s:
 Lady Diana (1961–1997)

138 **CHAPTER 3:
 THE QUINTESSENTIAL PIECES OF
 CLOTHING FROM THE 1990s**

 Baby tees – Baby doll dresses – Baggy jeans – Bike shorts – Bomber jackets – Cargo pants – Coogi sweaters – Corset tops – Faux-fur coats – Low-rise jeans – Nylon shell suits – One-strap overalls – Plaid flannel shirts – Platform shoes – Ripped jeans – Slip dresses – Spaghetti-strap tank tops – Swirl-print flared pants – Timberland shoes – Velour tracksuits – Velvet suits – Vinyl pants

208 Accessories

012	**EINLEITUNG: EIN JAHRZEHNT DES HOFFENS UND BANGENS**
014	**KAPITEL 1: FÜNF MODESTILE, DIE DIE 1990ER-JAHRE GEPRÄGT HABEN**
018	Grunge
026	Hip-Hop und der Aufstieg von Athleisure
038	Minimalismus
050	Dekonstruktion
060	Casual Chic und Preppy Style
066	Kultfrisuren der 1990er-Jahre
078	**KAPITEL 2: DIE MODESTARS DER 1990ER-JAHRE**
082	Eine neue Generation von Modedesignern
104	Der Aufstieg der Supermodels und Modefotografen
114	Mode in Kultserien und -filmen
124	Die goldene Zeit von MTV

130 Eine Modeikone der 1990er-Jahre: Lady Diana (1961–1997)

138 **KAPITEL 3: DIE UNVERZICHTBAREN KLEIDUNGSSTÜCKE AUS DEN 1990ER-JAHREN**

Baby Tees – Babydoll-Kleider – Baggy Jeans – Radlerhosen – Bomberjacken – Cargohosen – Coogi-Pullover – Korsett-Oberteile – Kunstpelzmäntel – Low-Rise-Jeans – Trainingsanzüge aus Nylon – One-Strap Overalls – Karierte Flanellhemden – Plateauschuhe – Ripped Jeans – Slip Dresses – Spaghettiträger-Tank-Tops – Schlaghose mit Swirl-Print – Timberland-Schuhe – Velours-Trainingsanzüge – Samtanzüge – Vinyl-Hosen

208 Accessoires

A decade of hope and anxiety

By the end of 1989, the Berlin Wall had just fallen; in the United Kingdom, Margaret Thatcher (the Iron Lady), a symbol of the triumphant 1980s, would fall a few months later; and in Arkansas, a young governor in his forties, Bill Clinton, was already getting ready for the next presidential election. The world, locked in place for years by the Cold War, was suddenly swept up in a wave of change and the Communist dictatorships of Europe were collapsing one after the other. On the other hand, China, whose power had wavered in June, saw the younger generation's hopes for freedom slip away. The dream of a conflict-free, "global" world where borders would fade away, was in many people's minds. The future looked full of both promise and uncertainty.

As in *Titanic*, the cult film of the decade, the illusion of progress would soon come up against the bitter reality of the world, and people would be tossed between crisis and hope: the Oslo Accords, brokering a truce between Israel and the Palestinian Authority, shortly followed the First Gulf War. The end of Yugoslavia ushered in a decade that would end with the Good Friday Agreement in Ireland. In a world inhabited, as the singer Mylène Farmer put it, by a disillusioned generation, fashion seemed ready to sink into grunge, despair and nihilism. However, beyond certain provocative trends, such as "ugly chic" and ripped jeans, fashion evolved in the direction of greater comfort, functionality, and increased diversity of style, as if to provide a protective cocoon for the wearer and meanwhile break away from uniformity.

This book explores the styles that characterised the 1990s and sheds new light on the unique alliance among designers, models, photographers, and brands that transformed the *fin-de-siècle* atmosphere of the decade into a melting pot from which today's fashion emerged.

Page 2: Once a symbol of rebellion against society, wearing ripped jeans became a popular, widely accepted trend in the 1990s.

Seite 2: Einst ein Symbol der Rebellion gegen die Gesellschaft, entwickelten sich die Ripped Jeans in den 1990er-Jahren zu einem beliebten und weithin akzeptierten Trend.

Pages 6-7: Fashion designer Jean Paul Gaultier surrounded by models, backstage picture, Paris, 1995

Seiten 6-7: Modedesigner Jean Paul Gaultier umgeben von Models, Backstage-Foto, Paris, 1995

Sharon Stone's minimalist outfit in *Basic Instinct*, 1992

Sharon Stones minimalistisches Ensemble in *Basic Instinct*, 1992

Ein Jahrzehnt des Hoffens und Bangens

Ende 1989 war gerade die Berliner Mauer gefallen, in Großbritannien wurde einige Monate später Margaret Thatcher alias die Eiserne Lady, ein Symbol der triumphalen 1980er-Jahre, gestürzt und in Arkansas bereitete sich ein junger Gouverneur namens Bill Clinton schon auf die nächste Präsidentschaftswahl vor. Die Welt, die jahrelang vom Kalten Krieg geprägt war, wurde plötzlich von einer Welle des Wandels erfasst. Die kommunistischen Diktaturen Europas brachen nacheinander zusammen, während die junge Generation in China ihre Hoffnungen auf Freiheit schwinden sah, nachdem sie die Macht der KP ins Wanken gebracht hatte. Viele Menschen träumten von einer konfliktfreien, „globalen" Welt ohne Grenzen. Man blickte voller Zuversicht, aber auch mit großer Ungewissheit in die Zukunft.

Wie in *Titanic*, dem Kultfilm des Jahrzehnts, wurde die Illusion des Fortschritts bald von der bitteren Realität eingeholt. Die Menschen fanden sich zwischen Krisen und einzelnen Lichtblicken wieder: Der Osloer Friedensprozess, der einen Waffenstillstand zwischen Israel und der Palästinensischen Autonomiebehörde hervorbrachte, folgte kurz auf den ersten Golfkrieg. Das Ende Jugoslawiens leitete ein Jahrzehnt ein, das mit dem Karfreitagsabkommen in Irland enden sollte. In einer Welt, die, wie die Sängerin Mylène Farmer es ausdrückte, von einer desillusionierten Generation bewohnt wurde, schien die Mode den Nihilismus dieser Deprimierten in einem Schmuddel-Look, dem sogenannten Grunge Style, widerzuspiegeln. Abgesehen von einigen provokanten Trends wie dem *Ugly Chic* und den zerrissenen Jeans entwickelte sich die Mode jedoch in Richtung Komfort, Funktionalität und größerer Vielfalt an Stilen. Sie scheint dem Träger einen schützenden Kokon bieten zu wollen und gleichzeitig aus der Uniformität auszubrechen.

Dieses Buch behandelt die Stile, die die 1990er-Jahre prägten, und wirft ein neues Licht auf die einzigartige Allianz zwischen Designern, Models, Fotografen und Marken, die die Fin-de-Siècle-Atmosphäre des Jahrzehnts in einen Schmelztiegel verwandelte, aus dem sich die heutige Mode entwickelte.

The Spice Girls, promotional poster for *Spice World*, 1997

Die Spice Girls, Werbeplakat für *Spice World*, 1997

Pages 14-15: Christian Dior's ready-to-wear fashion show, Spring 1995

Seiten 14-15: Christian Diors Frühjahrsmodenschau, 1995

Fünf Modestile, die die 1990er-Jahre geprägt haben

Grunge

Grunge fashion is to the 1990s what punk subculture was to the 1970s: a rebellious countercurrent that established itself as a significant social phenomenon, so much so that one cannot imagine the 1990s without mentioning this anti-fashion groundswell.

The term "grunge" itself was initially coined to describe a musical style that emerged among garage bands in the Seattle area in the 1980s: its sound was a fusion of punk with heavy metal, including "high levels of distortion, feedback, [and] fuzz effects". It was loud, angry, and seditious, as a reaction to the mainstream naïve optimism that prevailed in the early 1990s. By its nature, grunge music was able to channel the rebellion of a disenchanted generation deprived of ideals by the Reagan-Thatcher era, and grunge quickly expanded beyond music to become a way of life.

The popularity of grunge fashion owes much to the legendary couple Kurt Cobain, Nirvana's front man, and singer Courtney Love. Their anti-establishment attitude combined with resolutely fearless fashion choices made them the face of the X Generation. Their stylistic freedom showed absolute indifference to harmony, resulting in strange outfits that were as dissonant as grunge music, and would soon be adopted as a fashion statement.

The less you cared about fashion, the more you were into grunge style: a ripped stocking, an untucked hem, a faded, loose jumper, a pair of jeans with a hole in them suddenly became signs of belonging to a rebellious generation. Wearing an outdated floral blouse with a plaid skirt, a (poorly) hand-knit jumper, combat boots, and walking around with unwashed hair identified you as part of the grunge movement.

Grunge

Die Grunge-Mode ist für die 1990er-Jahre das, was die Punk-Subkultur für die 1970er-Jahre war: eine rebellische Gegenströmung, die sich als bedeutendes gesellschaftliches Phänomen etablierte, sodass man sich die 1990er-Jahre nicht mehr vorstellen kann, ohne diese Anti-Mode zu erwähnen.

Der Begriff Grunge wurde ursprünglich geprägt, um einen Musikstil zu beschreiben, der in den 1980er-Jahren von Garagenbands in der Gegend um Seattle geprägt wurde: Sein Sound war eine Mischung aus Punk und Heavy Metal und wies „starke Verzerrung, Rückkopplung [und] Fuzzbox" auf. Die Musik war laut, wütend und aufrührerisch und galt als Reaktion auf den naiven Optimismus des Mainstream, der in den frühen 1990er-Jahren vorherrschte. Es liegt auf der Hand, dass Grunge-Musik die Rebellion einer desillusionierten Generation, die durch die Reagan-Thatcher-Ära ihrer Ideale beraubt wurde, kanalisieren konnte. Grunge wurde schnell über die Musik hinaus zu einer Lebenseinstellung.

Ihre Popularität verdankt die Grunge-Mode vor allem dem legendären Paar Kurt Cobain, dem Frontmann der Band Nirvana, und der Sängerin Courtney Love. Ihre Anti-Establishment-Attitüde in Kombination mit ihrer furchtlosen Kleiderwahl machte sie zum Aushängeschild der Generation X.

Ihre stilistische Freiheit zeigte eine absolute Gleichgültigkeit gegenüber Harmonie, was zu seltsamen Outfits führte, die so dissonant waren wie die Grunge-Musik und bald zum Modestatement werden sollten.

Je weniger man sich um Mode kümmerte, desto mehr stand man auf den Grunge Style: Durch eine zerrissene Strumpfhose, einen kaputten Saum, einen verblichenen, weiten Pullover oder eine löchrige Jeans gehörte man plötzlich zu einer rebellischen Generation. Wenn man eine altmodische geblümte Bluse mit einem karierten Rock, einen (schlecht) gestrickten Pullover und Springerstiefel trug und mit ungewaschenen Haaren herumlief, wurde man als Teil der Grunge-Bewegung wahrgenommen.

Page 16-17: Anti-glamour icons par excellence: singers Kurt Cobain and Courtney Love, December 1992

Seite 16-17: Das Anti-Glamour-Paar schlechthin: die Sänger Kurt Cobain und Courtney Love, Dezember 1992

Page 18, 21: Models wearing grunge-inspired outfits designed by Marc Jacobs at the Perry Ellis fashion show, November 1992

Seiten 18, 21: Models in von Marc Jacobs entworfenen, Grunge-inspirierten Outfits bei der Perry-Ellis-Modenschau, November 1992

Cobain's favourite clothes on stage – oversized sweaters, distressed jeans, unbuttoned layered flannel shirts worn over t-shirts, and leopard jackets became emblems of the new style. In spite of its rough nature, where practicality prevailed over image and taste, grunge fashion had two characteristics that would ensure its success: it was affordable, since worn-out or damaged clothes were welcome, and shopping at thrift shops was the easiest way to achieve grunge style. Grunge was therefore part of a form of anti-consumerism at a time when fast fashion brands were taking off. Additionally, grunge injected a lovely touch of eccentricity that contributed to challenging the dogmas of fashion and convention, thus paving the way to a new generation of fashion designers with fresh, maverick ideas.

Thanks to one of them, 29-year-old Marc Jacobs, grunge fashion made a dramatic entrance on the catwalk on November 3rd, 1992. The spring 1993 grunge ready-to-wear collection he styled for the New York label Perry Ellis sent shockwaves through the fashion industry and led to vigorous protests from established fashion journalists. Jacobs was promptly fired by the brand, but achieved a reputation as an edgy, youth-minded fashion designer.

While the popularity of the grunge style fluctuated from the late 1990s onwards, it has not completely slipped off the radar: Yves Saint Laurent's Hedi Slimane paid a vibrant tribute to the grunge aesthetics in his spring 2013 collection. In 2018, Marc Jacobs reissued his iconic designs from 1993 as a capsule collection. Grunge has clearly influenced the hipster look, which has adopted the idea of comfort over image, and several elements of grunge style such as the flannel shirt, oversized sweaters, and ripped jeans remain in fashion.

Cobains Lieblingskleidung auf der Bühne – übergroße Pullover, zerschlissene Jeans, aufgeknöpfte Flanellhemden, die über T-Shirts getragen wurden, und Jacken mit Leopardenmuster – wurden zu Erkennungszeichen des neuen Stils. Trotz ihres rauen Charakters, bei dem Zweckmäßigkeit über Aussehen und gutem Geschmack steht, hatte die Grunge-Mode zwei Eigenschaften, die ihren Erfolg sicherte: Sie war erschwinglich, da abgenutzte oder beschädigte Kleidung willkommen war, und der Einkauf in Secondhand-Läden war der einfachste Weg, um sich im Grunge Style zu kleiden. Grunge wendete sich gegen den Konsum zu einer Zeit, in der Fast-Fashion-Marken auf dem Vormarsch waren. Darüber hinaus verlieh Grunge der Mode einen herrlichen Hauch von Exzentrik, der dazu beitrug, die Dogmen der Mode und der Konventionen in Frage zu stellen. So ebnete der Stil den Weg für eine neue Generation von Modedesignern mit frischen, unkonventionellen Ideen.

Dank einem von ihnen, dem 29-jährigen Marc Jacobs, feierte der Grunge Style am 3. November 1992 ein dramatisches Debüt auf dem Laufsteg. Die Grunge-Kollektion für das Frühjahr 1993, die er für das New Yorker Label Perry Ellis entwarf, schlug Wellen in der Modeindustrie und führte zu heftigen Protesten etablierter Modejournalisten. Jacobs wurde prompt von der Marke gefeuert, erwarb sich aber einen Ruf als unangepasster Modedesigner für junge Leute.

Auch wenn die Popularität des Grunge Style seit Ende der 1990er-Jahre schwankte, ist er nicht völlig von der Bildfläche verschwunden: Hedi Slimane von Yves Saint Laurent zollte der Grunge-Ästhetik in seiner Frühjahrskollektion 2013 einen lebhaften Tribut. 2018 legte Marc Jacobs seine ikonischen Entwürfe von 1993 in einer Capsule Collection neu auf. Grunge hat eindeutig den Hipsterlook beeinflusst, bei dem der Komfort vor dem Aussehen kommt. Verschiedene Elemente des Grunge Style wie Flanellhemden, übergroße Pullover und zerrissene Jeans sind so in Mode geblieben.

A soft version of the grunge look: Bridget Fonda and Matt Dillon in *Singles* (1992)

Eine milde Version des Grunge-Looks: Bridget Fonda und Matt Dillon in *Singles – Gemeinsam Einsam* (1992)

Page 23: Fishnet stockings, usually ripped, were a staple of the grunge look.

Seite 23: Fischnetzstrümpfe, üblicherweise zerrissen, waren ein fester Bestandteil des Grunge-Looks.

Hip-hop and the rise of athleisure

Over the 1990s, hip-hop evolved from a ghetto counterculture fueled by anger against racial discriminations into a widely accepted, mildly rebellious outlook on life that encompassed music, fashion, and arts.

While borrowing elements from the everyday life of African American ghettos, which at that stage were marked by drug trafficking and gang wars, hip-hop was to play as important a role as jazz did in the 1920s by highlighting the aesthetic genius of black America.

Just as street art tags derived from the signs used by New York gangs to mark the districts they controlled, hip-hop fashion was rooted in the clothing worn by street thugs and gangsters. One of the most iconic elements of hip-hop style, the 6-inch-high, waterproof Timberland nubuck boots, originally meant for construction workers and lumberjacks who had to work in the cold, were adopted by Brooklyn and Staten Island drug dealers for the sturdiness and comfort they provided during long selling sessions on snowy streets. From there, the Timbs showed up on the feet of the most prominent figures in the gangsta rap subculture, such as Notorious B.I.G. (who was assassinated in 1997). Rap magazine *Vibe* astutely noted that, "everyone from thugs to step teams were stalking, walking in their six-inch construction boots," as they "stood up beautifully to urban elements like concrete, barbed wire, and broken glass."

After reviving the old-fashioned, Prohibition-era gangster style in the late 1980s and the rise of Ghetto Fabulous fashion, the rap scene switched to a completely different dress code that allowed street musicians to perform spectacular dance movements. Oversized white tees and baggy jeans became the uniform of the hip-hop culture, along with Kangol bucket hats, bandanas, bling chains, and crop tops for girls. White tees and jeans might have been a nod to the rebellious youth of the 1950s embodied by Marlon Brando and James Dean, but instead of skin-tight clothing, the trend was for oversized garments, as if to counter the fitness culture prevalent in the 1980s.

Missy Elliott at the MTV Video Music Awards, 1997

Missy Elliott bei den MTV Video Music Awards, 1997

Hip-hop star Aaliyah performing at a concert, 1997

Sängerin Aaliyah bei einem Konzert, 1997

Hip-Hop und der Aufstieg von Athleisure

In den 1990er-Jahren entwickelte sich der Hip-Hop von einer Ghetto-Gegenkultur, die sich aus der Wut über Rassendiskriminierung speiste, zu einer allgemein akzeptierten, leicht rebellischen Lebensauffassung, die Musik, Mode und Kunst umfasste.

Indem er Elemente aus dem Alltag der afroamerikanischen Ghettos aufgriff, die zu dieser Zeit von Drogenhandel und Bandenkriegen geprägt waren, sollte der Hip-Hop eine ebenso wichtige Rolle spielen wie der Jazz in den 1920er-Jahren, indem er das ästhetische Genie des schwarzen Amerikas hervorhob.

So wie die sogenannten Graffiti-Tags von den Schildern abgeleitet sind, mit denen die New Yorker Gangs die von ihnen kontrollierten Stadtteile markierten, hat auch die Hip-Hop-Mode ihre Wurzeln in der Kleidung der Straßenschläger und Gangster. Eines der ikonischsten Elemente des Hip-Hop Style – die 6-Inch hohen, wasserdichten Nubuk-Stiefel von Timberland, die ursprünglich für Bauarbeiter und Holzfäller gedacht waren, die in der Kälte arbeiten mussten – wurde von Drogenhändlern in Brooklyn und Staten Island übernommen, weil sie bei langen Verkaufssessions auf verschneiten Straßen robust und bequem waren. Von da an tauchten die Timberland-Schuhe an den Füßen der prominentesten Personen der Gangsta-Rap-Subkultur auf, wie etwa Notorious B.I.G. (der 1997 ermordet wurde).

Das Rapmagazin *Vibe* bemerkte scharfsinnig, dass „jeder – von Schlägern bis hin zu Stepptänzern – in seinen 6-Inch hohen Baustiefeln auf der Pirsch war", da sie „städtischen Elementen wie Beton, Stacheldraht und zerbrochenem Glas hervorragend standhielten".

Nach der Wiederbelebung des altmodischen Gangsterstils aus der Zeit der Prohibition in den späten 1980er-Jahren und dem Aufkommen der Ghetto-Fabulous-Mode ging die Rapszene zu einer völlig anderen Kleiderordnung über, die es Straßenmusikern erlaubte, spektakuläre Tanzbewegungen auszuführen. Übergroße weiße T-Shirts und Baggy-Jeans wurden zusammen mit Kangol-Fischerhüten, Bandanas, Bling-Bling-Ketten und bauchfreien Tops für Mädchen zur Uniform der Hip-Hop-Kultur. Weiße T-Shirts und Jeans könnten eine Anspielung auf die rebellische Jugend der 1950er-Jahre sein, die von Marlon Brando und James Dean verkörpert wurde, aber statt hautenger Kleidung ging der Trend zu übergroßer Kleidung, als ob man der in den 1980er-Jahren vorherrschenden Fitnesskultur etwas entgegensetzen wollte.

Tracksuits and sneakers were a natural part of hip-hop fashion and everyday streetwear for break-dancers and others haunting the streets of deprived neighbourhoods. Some sportswear brands quickly understood the marketing potential of hip-hop to capture a young, cool audience not reached by traditional sports shops. In 1986, Adidas signed its first, non-athlete to a million-dollar endorsement deal, Run-D.M.C., the leading rap group of the day, after the resounding success of their single "My Adidas", thus turning hip-hop into a powerful business medium.

Trainingsanzüge und Turnschuhe gehörten selbstverständlich auch zur Hip-Hop-Mode und stellten die alltägliche Straßenkleidung von Breakdancern und Menschen dar, die sich in den Straßen sozial benachteiligter Viertel herumtrieben. Einige Sportbekleidungsmarken erkannten schnell das Marketingpotenzial des Hip-Hop, um ein junges, cooles Publikum zu erobern, das von traditionellen Sportgeschäften nicht erreicht wurde. 1986 schloss Adidas mit Run-D.M.C., der erfolgreichsten Rapgruppe der damaligen Zeit, nach dem durchschlagenden Erfolg ihrer Single „My Adidas" den ersten millionenschweren Werbevertrag mit Nicht-Sportlern ab und machte damit den Hip-Hop zu einem mächtigen Geschäftsmedium.

Page 28: Ralph Lauren's sportwear collection, New York, 1991-1992

Seite 28: Ralph Laurens Sportbekleidungskollektion, New York, 1991-1992

Page 29: Oversized outerwear, Ralph Lauren, New York, 1993

Seite 29: Oversize-Jacken, Ralph Lauren, New York, 1993

Athleisure at Donna Karan's ready-to-wear fashion show, New York, 1998

Athleisure bei der Modenschau von Donna Karan, New York, 1998

Under the influences of hip-hop, skateboarding culture, yoga, and fitness, athleisure-style took hold in fashion: leggings and sweatshirts as daywear became mainstream. Innovative athletics brands such as Champion, Fila, Nike, and Reebok were now considered trendsetters in the fashion industry and inspired high-end fashion labels to launch their own sportswear collections. Even fashion icon, Princess Diana, was often seen wearing a pair of fitted biker shorts with an oversized sweatshirt and a pair of white sneakers.

Unter dem Einfluss von Hip-Hop, der Skateboard-Kultur sowie Yoga und Fitness setzte sich der Athleisure Style in der Mode durch: Leggings und Sweatshirts wurden zur Alltagskleidung des Mainstream. Innovative Sportmarken wie Champion, Fila, Nike und Reebok galten nun als Trendsetter in der Modeindustrie und inspirierten hochwertige Modelabels zur Lancierung eigener Sportbekleidungskollektionen. Sogar Modeikone Prinzessin Diana wurde oft in einer engen Radlerhose mit einem übergroßen Sweatshirt und einem Paar weißer Turnschuhe gesehen.

Princess Diana in her biker shorts, white socks, and sneakers, 1995

Prinzessin Diana in einer ihrer Radlerhosen sowie weißen Socken und Turnschuhen, 1995

HIP-HOP AND THE RISE OF ATHLEISURE

Minimalism

"Simplicity is the ultimate sophistication."

Leonardo da Vinci

Leonardo da Vinci's visionary approach to sophistication seems to have guided many fashion designers in the 1990s. Some historians connect this quest for minimalist luxury with Mies van der Rohe's famous "Less is more" and with the rise of "good design" promoted by Dieter Rams, defined by clean lines, inobtrusive colours, no frills, and high-quality materials.

The idea of minimalist luxury in 1990s fashion was certainly not simply a new variant of the timeless elegance that defined classic good taste, it was rather a revolutionary vision aiming at the *unicum necessarium*, the simplest shape, as exemplified in Helmut Lang's purist collections that were partly inspired by utilitarian street wear. For the first time, models were running on the catwalk in flat shoes and make-up free to bring the focus to the clothes themselves, emphasising the sense of restraint animating Lang's collections and choice of colours. The designer masterfully used black and white with hints of more exuberant hues such as fuchsia and Yves-Klein-blue, thus avoiding any sense of austerity. Eccentric details such as transparent tops, paint-stained jeans, and bulletproof vests added a bit of controversy and fantasy. As fashion journalist Lorenzo Salamone wrote, "Everything that bore (Lang's) imprint, including the famous backstage photos signed by Juergen Teller, was both raw, elegant and almost hypnotic, although what made him so hypnotic was completely indefinable."

With controversial advertising campaigns surfing on the "heroin chic" trend, Calvin Klein maximised the impact of minimalism on fashion, and made minimalism look even more provocative than the exuberant, flashy opulence of the 1980s. His collections of underwear and jeans elevated these otherwise basic elements of clothing to the status of high fashion, and clever marketing around the brand led the public to perceive them as such.

Calvin Klein's sense of minimalism was characterised by the verticality of his designs, best shown in the slip dress, which became one of his signatures. As Elyssa Dimant wrote in her book *Minimalism and Fashion*, Calvin Klein (and Marc Jacobs, too) "found in the simple slip dress the perfect reductive form in which to clothe their high-end clientele." The simple structures made the luxury nearly invisible, far from the ostentatious glamour prevailing in the 1980s.

Pages 37, 38: Minimalist luxury as seen by Helmut Lang, 1997-1999

Seiten 37, 38: Minimalistischer Luxus im Sinne von Helmut Lang, 1997-1999

Minimalismus

„Einfachheit ist die höchste Stufe der Raffinesse."

Leonardo da Vinci

Leonardo da Vincis visionärer Ansatz von Raffinesse scheint viele Modedesigner in den 1990er-Jahren geleitet zu haben. Einige Historiker bringen dieses Streben nach minimalistischem Luxus mit Mies van der Rohes berühmtem Motto „Weniger ist mehr" und dem Aufkommen des von Dieter Rams propagierten „guten Designs" in Verbindung, das sich durch klare Linien, unaufdringliche Farben und hochwertige Materialien auszeichnet und keine Verzierungen aufweist.

Minimalistischer Luxus in der Mode der 1990er-Jahre war nicht einfach eine neue Variante der zeitlosen Eleganz, die den klassischen guten Geschmack ausmacht, sondern vielmehr eine revolutionäre Vision, die auf das *unicum necessarium*, die einfachste Form, setzte, wie sie in den puristischen Kollektionen von Helmut Lang zum Ausdruck kam, die zum Teil von utilitaristischer Streetwear inspiriert waren. Zum ersten Mal liefen die Models in flachen Schuhen und ungeschminkt über den Laufsteg, um die Zurückhaltung zu unterstreichen, die Langs Kollektionen und Farbwahl prägt. Der Designer setzte gekonnt auf Schwarz und Weiß mit Anklängen von üppigeren Farben wie Fuchsia und Yves-Klein-Blau und vermied so jeden Eindruck von Strenge. Exzentrische Details wie transparente Oberteile, mit Farbe bekleckerte Jeans und kugelsichere Westen sorgten für Kontroversen und Fantasie. Der Modejournalist Lorenzo Salamone schrieb: „Alles, was (Langs) Handschrift trug, einschließlich der berühmten Backstage-Fotos, die von Juergen Teller geschossen wurden, war sowohl roh und elegant als auch fast hypnotisch, obwohl das, was ihn so hypnotisch machte, völlig undefinierbar war."

Mit kontroversen Werbekampagnen, die aus dem Heroin-Chic-Trend Kapital schlugen, maximierte Calvin Klein den Einfluss des Minimalismus auf die Mode und machte den Minimalismus noch provokanter als die auffällige und überschwängliche Opulenz der 1980er-Jahre. Seine Unterwäsche- und Jeanskollektionen hoben diese ansonsten einfachen Kleidungsstücke auf die Ebene der High Fashion und ein geschicktes Marketing rund um die Marke führte dazu, dass sie von der Öffentlichkeit auch als solche wahrgenommen wurden.

Calvin Kleins Sinn für Minimalismus zeichnete sich durch die Vertikalität seiner Entwürfe aus, die sich am besten am Slipkleid zeigt, das zu einem seiner Markenzeichen wurde. Wie Elyssa Dimant in ihrem Buch *Minimalism and Fashion* schreibt, fand Calvin Klein (und auch Marc Jacobs) „in dem einfachen Slipkleid die perfekte reduzierte Form, um ihre High-End-Klientel einzukleiden." Die einfachen Strukturen machten den Luxus des Kleidungsstücks fast unsichtbar, was vom protzigen Glamour der 1980er-Jahre weit entfernt war.

In Jil Sander's own words, "minimalism sometimes sounds too hollow." She, therefore, developed the concept of "purism", which has its roots in the Bauhaus movement, with its focus on functionality and simplicity: "Streamlined beauty, clear structures, reduction to the essential and free movement. But functional rationality is only the backbone of my work. I always look for contemporary forms of sophistication and sensual simplicity. I want fashion to be liberating in a subtle way." The fact that every modern woman can imagine herself wearing one of Sander's designs greatly contributed to the success of her purist collections and earned her the nickname "the queen of less".

Some well-established luxury brands, such as Prada, followed this "leaner luxury" trend to stay in phase with the time. At the dawn of the 1990s, Miuccia Prada designed a black backpack made of nylon, breaking with the tradition of leather accessories that had made the reputation of the brand. Its minimalist look and lightweight functionality seduced customers far beyond the usual circle of luxury goods buyers, thus proving that less could mean better.

Pages 40, 43: A vision of minimalist, modern elegance by Jil Sander. Ready-to-wear collection, Autumn 1991

Seite 40, 43: Jil Sanders Vision von minimalistischer, moderner Eleganz. Modekollektion, Herbst 1991

Für Jil Sander „klingt der Minimalismus manchmal zu hohl", weshalb sie das Konzept des Purismus entwickelte, das seine Wurzeln in der Bauhaus-Bewegung hat, die sich auf Funktionalität und Einfachheit konzentriert: „Schlanke Schönheit, klare Strukturen, Reduktion auf das Wesentliche und freie Bewegung. Aber die funktionale Rationalität ist nur das Rückgrat meiner Arbeit. Ich suche immer nach zeitgenössischen Formen von Raffinesse und sinnlicher Einfachheit. Ich möchte, dass Mode auf subtile Art und Weise befreiend wirkt." Die Tatsache, dass sich jede moderne Frau vorstellen kann, einen von Sanders Entwürfen zu tragen, trug wesentlich zum Erfolg ihrer puristischen Kollektionen bei und brachte ihr den Spitznamen „the queen of less" ein.

Einige etablierte Luxusmarken wie Prada folgten diesem Trend des schlanken Luxus, um mit der Zeit zu gehen. Zu Beginn der 1990er-Jahre entwarf Miuccia Prada einen schwarzen Rucksack aus Nylon und brach so mit der Tradition der Lederaccessoires, die den Ruf der Marke begründet hatten. Sein minimalistisches Aussehen und sein geringes Gewicht zogen Käufer an, die weit über den üblichen Kundenkreis von Luxusmarken hinausgingen, und bewiesen damit, dass weniger auch besser sein kann.

Pages 44, 45: Some of Donna Karan's modern minimalist designs, ready-to-wear show, 1998

Seiten 44, 45: Einige der modernen minimalistischen Kreationen von Donna Karan, Prêt-à-porter-Show, 1998

Pages 46, 47: Kate Moss at Calvin Klein's ready-to-wear fashion show, New York, 1997

Seiten 46, 47: Kate Moss bei Calvin Kleins Prêt-à-porter-Modenschau, New York, 1997

MINIMALISM

Deconstruction

After emerging as a philosophical, post-structuralist concept in the 1960s, mainly under the influence of French philosopher Jacques Derrida, deconstruction extended to other disciplines such as literary studies, graphic arts and particularly architecture – Frank Gehry and Zaha Hadid were among the most famous deconstructivist architects.

Deconstruction reached fashion in the late 1980s, when a group of Japanese designers, including Rei Kawakubo, Issey Miyake and Yohji Yamamoto, challenged the rules of fashion to literally deconstruct the feminine silhouette and introduce elements of imperfection, unevenness, and asymmetry. In the same deconstructivist spirit of breaking down traditional positions of Western thought, these fashion designers strived to blur the lines between masculine and feminine, as underscored by the name of the brand founded by Rei Kawakubo, Comme des Garçons ("like the boys" in French).

By questioning the definitions of elegance and taste, juxtaposing classical and provocative elements and shapes in her designs, and toying with atypical fabrics such as boiled, shrunk wool (in her 1994 Metamorphosis collection), Rei Kawakubo revolutionised the vocabulary of clothing. Just like Kawakubo, Yohji Yamamoto drew his aesthetic inspiration from Vivienne Westwood's punk fashion to create high fashion garments that look ragged, with uneven hems and deliberately neglected finishings.

"I think perfection is ugly. Somewhere in the things humans make, I want to see scars, failure, disorder, distortion."

Yohji Yamamoto

Pages 48 and 51: Some of Yohji Yamamoto's deconstructivist designs, early 1990s

Seiten 48 und 51: Einige der dekonstruktivistischen Kreationen von Yohji Yamamoto, Anfang der 1990er-Jahre

Dekonstruktion

Nach ihrer Entstehung als philosophisches, poststrukturalistisches Konzept in den 1960er-Jahren unter dem maßgeblichen Einfluss des französischen Denkers Jacques Derrida weitete sich die Dekonstruktion auf andere Disziplinen wie die Literaturwissenschaft, die bildenden Künste und vor allem die Architektur aus. Frank Gehry und Zaha Hadid gehören zu den bekanntesten dekonstruktivistischen Architekten.

Die Dekonstruktion erreichte die Mode in den späten 1980er-Jahren, als eine Gruppe japanischer Designer, darunter Rei Kawakubo, Issey Miyake und Yohji Yamamoto, die Regeln der Mode in Frage stellten, um die weibliche Silhouette buchstäblich zu dekonstruieren und Elemente der Unvollkommenheit, Unebenheit und Asymmetrie einzuführen. Im gleichen dekonstruktivistischen Sinne, der traditionelle Positionen des westlichen Denkens hinterfragt, versuchten diese Modedesigner, die Grenzen zwischen maskulin und feminin zu verwischen, wie der Name der von Rei Kawakubo gegründeten Marke Comme des Garçons („wie die Jungs") verdeutlicht.

Indem sie die Definitionen von Eleganz und gutem Geschmack in Frage stellte, klassische und provokante Elemente und Formen in ihren Entwürfen einander gegenüberstellte und mit untypischen Stoffen wie gekochter, eingelaufener Wolle (in ihrer Kollektion Metamorphosis von 1994) spielte, revolutionierte Rei Kawakubo das Bekleidungsvokabular.

Genau wie Kawakubo ließ sich auch Yohji Yamamoto von der Punkmode Vivienne Westwoods inspirieren, um Haute-Couture-Kleidungsstücke zu entwerfen, die durch ungleiche Säume und unfertige Abschlüsse wie Lumpen aussahen.

„Ich finde Perfektion hässlich. Irgendwo in den Dingen, die Menschen machen, möchte ich Narben, Versagen, Unordnung, Entstellung sehen."

Yohji Yamamoto

DEKONSTRUKTION

In the wake of his Japanese peers, Belgian fashion designer Martin Margiela, who was trained by Jean Paul Gaultier and influenced by the work of Rei Kawakubo, launched his second personal collection in the autumn of 1989, with a focus on deconstruction and anti-conformity. His use of upcycled fabrics and garments, disproportionate, asymmetric shapes, as well as fashion shows that took place in the most unconventional venues – a derelict building in northern Paris, a cemetery or a fire station, for example – were all in clear defiance of the rules that prevailed in the fashion world at the time. In addition, Margiela stayed backstage at the end of the shows, contrary to custom, and no photographs of him circulated, maintaining a strict, voluntary anonymity the designer required. Margiela's vision of fashion has had a lasting influence on the new generations of designers, such as Belgian Glenn Martens, whose collections often refer to the deconstructivist trends of the 1990s.

Dem Vorbild seiner japanischen Kollegen folgend lancierte der belgische Modedesigner Martin Margiela, der von Jean Paul Gaultier ausgebildet und von Rei Kawakubo beeinflusst wurde, im Herbst 1989 seine zweite eigene Kollektion, die auf Dekonstruktion und Antikonformität ausgerichtet war. Die Verwendung von upgecycelten Stoffen und Kleidungsstücken sowie unproportionierte, asymmetrische Formen und Modenschauen an den ungewöhnlichsten Orten, wie einem heruntergekommenen Gebäude im Norden von Paris, einem Friedhof oder einer Feuerwache, widersprachen eindeutig den Regeln der damaligen Modewelt. Außerdem blieb Margiela entgegen den Gepflogenheiten am Ende der Shows hinter der Bühne und es wurden keine Fotos von ihm veröffentlicht, um die vom Designer geforderte strikte Anonymität zu wahren. Margielas Vision von Mode hat die neuen Generationen von Designern nachhaltig beeinflusst, wie zum Beispiel den Belgier Glenn Martens, dessen Kollektionen häufig auf die dekonstruktivistischen Trends der 1990er-Jahre verweisen.

A deconstructivist denim dress by Martin Margiela, 1999

Ein dekonstruktivistisches Denim-Kleid von Martin Margiela, 1999

Pages 54-57: Comme des Garçons' ready-to-wear "Tough and Tender" deconstructivist collection, Paris, 1998

Seiten 54-57: Die dekonstruktivistische Kollektion "Tough and Tender" von Comme des Garçons, Paris, 1998

DECONSTRUCTION

55

56

DECONSTRUCTION 57

Casual chic and preppy style

"Nothing is more beautiful than freedom of the body."

Coco Chanel

With the development of sportswear in the 1920s, casual style found its rightful place in fashion and grew steadily throughout the 20th century. Polo shirts and pleated skirts, originally designed for playing tennis, soon gained popularity as leisurewear, and became acceptable for casual days out or for sailing. At the same time, Coco Chanel was reinventing women's looks by adapting garments from men's wardrobes and using fabrics such as tweed and jersey for additional comfort and freedom of movement – an essential notion in the evolution of fashion when we think of the constraints imposed by the corset at the beginning of the 20th century.

Casual style reached a new stage in the 1950s, when a new generation of anti-conformists and protesters adopted jeans and t-shirts as the emblems of their rebellion against the established order. Casual wear was no longer what you wore "off-duty", it had transformed into a relaxed style in perfect tune with the spirit of the 1960s and 1970s, aggregating more and more elements in the wake of new trends: jogging suits, sport shoes, flannel shirts and flip flops to name but a few.

In the early 1990s, businesses introduced the option of "casual Fridays", inviting their employees to dress more casually on Fridays, in an attempt to make the staff feel more relaxed and comfortable ahead of the weekend. It was a small reward with no cost to the companies, and motivated people to enjoy the last day of the working week. But you were not expected to show up in shorts and sandals, instead a new variant of the casual style, called "business casual" or "smart casual" surfaced, which mixed formal clothes with less conventional, yet well-fitting and neat elements. You would typically wear a blouse with a pencil leather skirt, a suit with a (not too loose) t-shirt, chinos with a blazer and polo shirt.

Princess Diana wearing checkered capris and ballerinas at Highgrove, early 1990s

Prinzessin Diana in karierten Caprihosen und Ballerinas in Highgrove, Anfang der 1990er-Jahre

CASUAL CHIC AND PREPPY STYLE

Casual Chic und Preppy Style

„Nichts ist schöner als die Freiheit des Körpers."

Coco Chanel

Mit der Entwicklung der Sportbekleidung in den 1920er-Jahren fand der Casual Style seinen Platz in der Mode und baute ihn im Laufe des 20. Jahrhunderts weiter aus. Poloshirts und Plisseeröcke, die ursprünglich fürs Tennisspielen gedacht waren, wurden bald als Freizeitkleidung beliebt und waren für legere Ausflüge oder zum Segeln geeignet. Zur gleichen Zeit erfand Coco Chanel die Damenmode neu, indem sie Kleidungsstücke aus der Herrengarderobe adaptierte und Stoffe wie Tweed und Jersey für zusätzlichen Komfort und Bewegungsfreiheit verwendete. Dies stellte eine wesentliche Entwicklung der Mode dar, wenn man an die Einschränkungen denkt, die das Korsett zu Beginn des 20. Jahrhunderts mit sich brachte.

In den 1950er-Jahren etablierte sich der Casual Style, als eine neue Generation von Antikonformisten und Demonstranten Jeans und T-Shirts zu Emblemen ihrer Rebellion gegen die etablierte Ordnung machte. Die Freizeitbekleidung war nicht mehr das, was man außerhalb des Büros trug, sondern hatte sich in einen entspannten Lebensstil verwandelt, der dem Geist der 1960er- und 1970er-Jahre entsprach und im Zuge der neuen Trends immer mehr Elemente vereinte: Jogginganzüge, Sportschuhe, Flanellhemden und Flipflops, um nur einige zu nennen.

Anfang der 1990er-Jahre führten Unternehmen Casual Fridays ein und ermöglichten ihren Mitarbeitern so, sich freitags legerer zu kleiden, damit sie sich vor dem Wochenende entspannter und wohler fühlten. Dies war eine kleine Belohnung, die die Unternehmen nichts kostete und die Menschen motivierte, den letzten Tag der Arbeitswoche zu genießen. Es wurde aber nicht erwartet, dass man in Shorts und Sandalen auftauchte, und so entstand eine neue Variante des legeren Stils namens *Business Casual* oder *Smart Casual*, die formelle Kleidung mit weniger konventionellen, aber gut sitzenden und gepflegten Elementen mischte. Typischerweise trägt man eine Bluse zu einem Bleistiftrock aus Leder, einen Anzug mit einem (nicht zu weiten) T-Shirt, eine Chinohose mit einem Blazer und einem Rollkragenpullover.

The perfect match for a smart casual look: wearing a luxury handbag paired with sneakers

Der perfekte Mix für einen eleganten Freizeitlook: eine luxuriöse Handtasche kombiniert mit Sneakers

Casual chic is, in a way, the off-duty version of smart casual, when you feel free to wear a pair of jeans and sneakers with more sophisticated garments. It was in the zeitgeist of the decade to blur the borders between styles, or to combine them to maximize both the comfort and the elegance of your look. The goal was to feel relaxed and stylish at once. It turned out to be a lasting trend, which has endured and gained even more importance now.

Although more elitist in essence, the preppy style, whose origins date back to the fashion and lifestyle of Ivy League students in the 1920s, enjoyed a sudden revival in the course of the 1980s, thanks to the success of the *Official Preppy Handbook* by Lisa Birnbach, a somewhat satirical publication about this upper-class subculture that sold more than a million copies and contributed to making preppy fashion codes visible to a wider public. The popularity of the preppy style continued in the 1990s, under the influence of Lady Diana, who was often spotted in ankle-length gingham pants and moccasins – two must-have pieces of preppy fashion, along with pleated skirts, cardigans, plaid blazers and khakis, and sweaters knotted over shoulders. Fashion designers such as Ralph Lauren and Tommy Hilfiger took advantage of the trend to establish their brands and offer high profile, yet fairly priced preppy-style garments, capitalising on the preppy customers' desire for quality and brands.

A preppy style icon of the 1990s: Alicia Silverstone as Cher Horowitz in *Clueless* (1995)

Eine Preppy-Modeikone der 1990er-Jahre: Alicia Silverstone als Cher Horowitz in *Clueless – Was sonst!* (1995)

Casual Chic ist gewissermaßen die Freizeitvariante von Smart Casual, bei der man ein Paar Jeans und Turnschuhe zu formelleren Kleidungsstücken trägt. Es lag im Zeitgeist dieses Jahrzehnts, die Grenzen zwischen den Stilen zu verwischen oder sie zu kombinieren, um sowohl den Komfort als auch die Eleganz des eigenen Looks zu maximieren. Das Ziel war es, sich sowohl entspannt als auch schick zu fühlen. Dies erwies sich als nachhaltiger Trend, der anhält und in letzter Zeit sogar noch an Bedeutung gewonnen hat.

Obwohl der *Preppy Style* im Kern eher elitär ist, erlebte er in den 1980er-Jahren ein plötzliches Revival. Seine Ursprünge gehen auf die Mode und den Lebensstil der Studenten der Ivy League in den 1920er-Jahren zurück. Das erneute Aufkommen dieses Stils ist dem Erfolg des *Official Preppy Handbook* von Lisa Birnbach zu verdanken, einer etwas satirischen Publikation über diese *Upper-Class*-Subkultur, die sich mehr als eine Million Mal verkaufte und dazu beitrug, die Preppy-Moderegeln für jedermann zugänglich zu machen. Die Popularität des Preppy Style setzte sich in den 1990er-Jahren unter dem Einfluss von Lady Diana fort, die oft in knöchellangen karierten Hosen und Mokassins gesehen wurde – zwei Must-Haves des Preppy Style zusammen mit Plisseeröcken, Strickjacken, karierten Blazern und Khakis mit über den Schultern drapierten Pullovern. Modedesigner wie Ralph Lauren und Tommy Hilfiger griffen den Trend auf, um ihre Marken zu etablieren und hochwertige, aber dennoch preisgünstige Kleidungsstücke im Preppy Style anzubieten, wobei sie vom Wunsch der Anhänger dieses Stils nach Qualität und Marken profitierten.

Cult hairstyles of the 1990s

Unsurprisingly, the haircuts in trend during the 1990's reflected the diversity and originality of fashion styles that marked the decade: from edgy, grunge-inspired spiked pixies to more classic cuts seen in a New York based sitcom, you could easily find something to your taste. A particular emphasis was placed on practicality and new accessories – scrunchies, butterfly clips, and hair claws. A selection of the 10 most iconic 1990s haircuts, which have stood the test of time, is featured in the following pages.

Es überrascht nicht, dass die Frisuren, die in den 1990er-Jahren im Trend lagen, die Vielfalt und Originalität der Modestile widerspiegelten, die das Jahrzehnt prägten: Vom stacheligen Pixie, der vom Grunge inspiriert wurde, bis hin zu klassischeren Schnitten, die durch eine in New York spielende Sitcom populär wurden, war für jeden etwas Passendes dabei. Besonderen Wert wurde auf Praktikabilität und neue Accessoires wie Haargummis aus Stoff und Haarspangen in verschiedenen Formen und Größen gelegt. Auf den folgenden Seiten finden Sie die 10 kultigsten Haarschnitte aus den 1990er-Jahren, die die Zeiten überdauert haben.

Kultfrisuren der 1990er-Jahre

Jennifer Aniston's unforgettable hairstyle for *Friends*, 1994

Jennifer Anistons unvergessliche Frisur aus *Friends*-Zeiten, 1994

CULT HAIRSTYLES OF THE 1990s

The Rachel

As journalist Jason Serafino put it, "*Friends* reached its cultural zenith when it managed to transform a simple hairstyle into a global talking point, as millions of women in the '90s flocked to salons all wanting one thing: 'The Rachel.'"

This voluminous, just-above-the-shoulders cut with lots of layers was invented for Jennifer Aniston's character, Rachel Green, by stylist Chris McMillan in 1995. It looked sophisticated yet natural and was soon adopted by other celebrities such as actresses Meg Ryan and Jessica Alba.

Cher Horowitz hair

Cher Horowitz's frizz-free, silky, polished hair is one of the most lasting legacies of *Clueless*, a cult comedy about teens in the 1990s. This timelessly elegant haircut is both smooth and soft, with a fairly natural C shape on the ends. It provides a touch of femininity even when you opt for a unisex dress code.

Rachel-Schnitt

Wie der Journalist Jason Serafino es ausdrückte, „erreichte *Friends* seinen kulturellen Höhepunkt, als es der Serie gelang, eine einfache Frisur in ein weltweites Gesprächsthema zu verwandeln. Millionen von Frauen strömten in den 90er-Jahren in die Friseursalons und wollten alle nur eine Frisur haben: ‚den Rachel-Schnitt'."

Dieser voluminöse, bis knapp über die Schultern reichende Schnitt mit vielen Stufen wurde 1995 von dem Stylisten Chris McMillan für Jennifer Anistons Figur der Rachel Green kreiert. Die Frisur sah raffiniert und doch natürlich aus und wurde bald von anderen Prominenten wie den Schauspielerinnen Meg Ryan und Jessica Alba übernommen.

Cher Horowitz' Haar

Cher Horowitz' glattes, seidig-glänzendes Haar ist eines der Vermächtnisse von *Clueless*, einer Kultkomödie über Teenager aus den 1990er-Jahren. Dieser zeitlos elegante Haarschnitt hat eine ziemlich natürlich wirkende Welle an den Spitzen. Die Frisur sorgt für einen Hauch von Weiblichkeit, auch wenn Sie sich für Unisexkleidung entscheiden.

Alicia Silverstone as Cher Horowitz in *Clueless*, 1994

Alicia Silverstone als Cher Horowitz in *Clueless – Was sonst!*, 1994

Braids

Braids rarely go out of fashion. In the 1990s, Janet Jackson made the headlines with her chunky braids in *Poetic Justice*, a romantic drama released in 1993. They were sometimes matched with Bantu knots. Micro braids, beaded braids (often associated with Serena and Venus Williams), and heart braids (with a heart-shaped base) were also popular.

Pigtail braids

Remember Britney Spears' *Baby One More Time* look back in 1998? Pigtails have enjoyed a recent revival thanks to Hailey Bieber and Kendall Jenner. However, the pop music star was not the only celebrity of the time to enjoy and promote pigtail braids, as supermodel Claudia Schiffer made them one of her signature hairstyles.

Braids

Braids kommen selten aus der Mode. In den 1990er-Jahren sorgte Janet Jackson mit ihren dicken Braids in *Poetic Justice*, einem romantischen Drama von 1993, für Schlagzeilen. Manchmal wurden sie mit Bantuknoten kombiniert. Beliebt waren auch Micro Braids, Braids mit Perlen, die oft mit Serena und Venus Williams in Verbindung gebracht werden, und Braids mit einem herzförmigen Ansatz.

Bauernzopf

Erinnern Sie sich an den Look von Britney Spears in ihrem Musikvideo zu *Baby One More Time* von 1998? Zöpfe haben dank Hailey Bieber und Kendall Jenner vor Kurzem ein Revival erlebt. Der Popstar war jedoch nicht die einzige Prominente dieser Zeit, die Zöpfe liebte, denn auch Supermodel Claudia Schiffer machte sie zu einer ihrer typischen Frisuren.

Pixie

Popularised by star actresses Audrey Hepburn and Jean Seberg in the 1950s, this short cut has symbolised non-conformity and freedom. Winona Ryder brought it back into fashion in the early 1990s as the hairstyle for modern, free-minded women.

The pixie's grunge version, with spiked hair, was halfway between rebellion and deconstruction.

Undone curls

A hallmark of the 1990s, undone curls were a must-have if you wanted to look like Nicole Kidman, Julia Roberts, Sarah Jessica Parker, or Mariah Carey, to name but a few curly-haired stars of the decade.

Pixie

In den 1950er-Jahren wurde dieser Kurzhaarschnitt von den weltberühmten Schauspielerinnen Audrey Hepburn und Jean Seberg populär gemacht und symbolisiert seither Unangepasstheit und Freiheit. Winona Ryder brachte ihn Anfang der 1990er-Jahre als Frisur für moderne, freigeistige Frauen wieder in Mode.

Die Grunge-Variante des Pixies mit stacheligen Haaren war zwischen Rebellion und Dekonstruktion angesiedelt.

Beach Waves

Beach Waves waren in den 1990er-Jahre sehr beliebt und ein Muss, wenn man wie Nicole Kidman, Julia Roberts, Sarah Jessica Parker oder Mariah Carey aussehen wollte, um nur einige der Stars des Jahrzehnts zu nennen, die diesen Trend bevorzugt trugen.

Face-framing tendrils

Face-framing tendrils, often paired with a ponytail, a headband, or a bun, were all the rage in the 1990s: from Pamela Anderson to Jennifer Lopez, and from Kirsten Dunst to Posh Spice, tendrils were adorning any kind of face.

Baby Bangs

Whether cut straight or not, baby bangs gave you an unmistakably little girlish look. They cover the upper part of the forehead, far above the eyebrows. The hairstyle was first popular in the 1950s and was endorsed in the 1990s by celebrities such as Natalie Portman, Drew Barrymore, and Courtney Cox. It went viral at the turn of the millennium thanks to French actress Audrey Tautou's character in *Amélie*.

Gesichtsumrahmende Strähnen

Gesichtsumrahmende Strähnen, die oft mit einem Pferdeschwanz, einem Stirnband oder einem Dutt kombiniert wurden, waren in den 1990er-Jahren der letzte Schrei: Bei vielen Prominenten – von Pamela Anderson über Jennifer Lopez und Kirsten Dunst bis hin zu Posh Spice – schmückten Strähnen das Gesicht.

Baby Bangs

Ob gerade geschnitten oder nicht, Baby Bangs verleihen Ihnen einen eindeutig mädchenhaften Look. Diese Ponyfrisur bedeckt nur den oberen Teil der Stirn und hört weit oberhalb der Augenbrauen auf. Die Frisur erfreute sich erstmals in den 1950er-Jahren größerer Beliebtheit und wurde in den 1990er-Jahren von Stars wie Natalie Portman, Drew Barrymore und Courtney Cox getragen. Dank der Figur der *Amélie*, die die französische Schauspielerin Audrey Tautou in dem Film verkörpert, lag der Haarschnitt um die Jahrtausendwende besonders im Trend.

Page 74: Kirsten Dunst with face-framing tendrils, 1999

Seite 74: Kirsten Dunst mit gesichtsumrahmenden Strähnen, 1999

Audrey Tautou with her legendary baby bangs in *Amélie*, 2001

Audrey Tautou und ihre legendären Baby Bangs in *Die fabelhafte Welt der Amélie*, 2001

Finger-raked bob

Even more than the pixie, the finger-raked bob is tightly linked to Winona Ryder's style. The ultimate Gen X brunette transformed feigned carelessness into a chic trend. But she would still look like an enfant terrible.

Chunky highlights

Chunky highlights are a signature style of the 1990s. Many celebrities of the time, from Geri Halliwell to Jennifer Aniston and Sarah Jessica Parker, enjoyed the attention-grabbing effect the contrast of lighter and darker colours created. Their popularity was also due to the fact that they were equally suited to short or long hair.

Page 76: Actress Winona Ryder and her signature finger-raked pixie, 1997

Seite 76: Die Schauspielerin Winona Ryder und ihr charakteristischer Bixie, 1997

Bixie

Mehr noch als der Pixie ist der Bixie eng mit dem Stil von Winona Ryder verbunden. Die ultimative Brünette der Generation X verwandelte scheinbare Sorglosigkeit in einen schicken Trend. Sie sieht damit aber immer noch wie ein Enfant terrible aus.

Blocksträhnen

Blocksträhnen sind besonders typisch für die 1990er-Jahre. Viele Prominente dieser Zeit – von Geri Halliwell über Jennifer Aniston bis hin zu Sarah Jessica Parker – genossen den aufmerksamkeitserheischenden Effekt, den der Kontrast zwischen hellen und dunklen Farben erzeugte. Ihre Beliebtheit beruhte auch darauf, dass sie für kurzes und langes Haar gleichermaßen geeignet sind.

Fashion stars
of the 1990s

Die Modestars der 1990er-Jahre

A new generation of fashion designers

The extraordinary creative boom that fashion experienced throughout the 1990s owed much to the emergence of new maverick designers and to the profusion of innovative talents who were eager to reinvent fashion. Who were the masters of the creative game in the 1990s and what was their role? From minimalism to grunge deconstruction to unbridled exuberance, every trend contributed to making the 1990s a golden era.

A member of the Antwerp Six, a group of young Belgian fashion designers known for their deconstructivist approach, **Ann Demeulemeester** (b. 1959) launched her first collection in 1985, inspired by the aesthetics of punk and Vivienne Westwood's designs. "Known for her elegant tailoring and dark yet glamorous aesthetic, she created a serene and darkly romantic world with an intriguing mix of edgy rebellion and sophistication."

Tom Ford's (b. 1961) 1990s are closely linked with his tenure at Gucci, a brand he contributed to saving from near bankruptcy with designs that combined classic chic, transgressive sensuality, and whimsical bling. As photographer Mario Testino recalled, "Back in the early 90's Tom Ford called me to work on a campaign for Gucci. Carine (Roitfeld) and I had a certain style to our pictures that he thought went well with his ideas for his new post as creative director of the brand. We embarked on a wonderful journey, as he was the first commercial client that did not hold us back, but pushed us. He wanted images that would make people stop and look."

Despite some highly contentious comments that have tarnished his reputation, no one can deny **John Galliano's** (b. 1960) creative genius. After studies at Central St. Martins in the mid-1980s and an early career start in London, Galliano moved to Paris in 1989, where, with Anna Wintour's enthusiastic support, he began to break through as a leading fashion designer. Halfway between Salvador Dalí and Oscar Wilde, the spirit that drives Galliano's collections is characterised by decadent opulence and a provocative sense of mockery, with influences drawn from the French Revolution and Napoleonic Empire. He was the first British designer to take over the artistic direction of a French brand, Givenchy in 1995 and then Dior in 1996, where his edgy, extravagant collections reinvigorated the prestigious house.

An exuberant evening gown by John Galliano for Dior's ready-to-wear collection, Spring 1999

Ein opulentes Abendkleid von John Galliano für Diors Prêt-à-porter-Kollektion, Frühjahr 1999

Pages 78-79: Claudia Schiffer and Cindy Crawford at the Chanel ready-to-wear fashion show, Paris, Spring 1993

Seiten 78-79: Claudia Schiffer und Cindy Crawford bei einer Chanel-Modenschau, Paris, Frühjahr 1993

Eine neue Generation von Modedesignern

Die außergewöhnlich kreative Phase, die die Mode in den 1990er-Jahren erlebte, war zu einem großen Teil den jungen, unkonventionellen Designern und Talenten mit Innovationsgeist zu verdanken, die die Mode neu erfinden wollten. Wer waren die Meister dieser kreativen Strömungen in den 1990er-Jahren und wie haben sie die Mode beeinflusst? Von Minimalismus über die Dekonstruktion des Grunge bis hin zu ungezügelter Überschwänglichkeit – jeder Trend trug dazu bei, die 1990er-Jahre zu einer goldenen Ära zu machen.

Als Mitglied der Antwerp Six, einer Gruppe junger belgischer Modedesigner, die für ihren dekonstruktivistischen Ansatz bekannt waren, brachte **Ann Demeulemeester** (geb. 1959) 1985 ihre erste Kollektion heraus, die von der Ästhetik des Punks und den Entwürfen von Vivienne Westwood inspiriert war. „Sie war bekannt für ihre elegante Schneiderkunst und ihre dunkle, glamouröse Ästhetik. Mit einer faszinierenden Mischung aus Rebellion und Raffinesse schuf sie eine ernste, düster-romantische Welt."

Die 1990er-Jahre von **Tom Ford** (geb. 1961) sind eng mit seiner Tätigkeit bei Gucci verbunden – einer Marke, die er mit seinen Entwürfen, die klassischen Chic, transgressive Sinnlichkeit und skurrilen Bling-Bling kombinierten, vor dem Bankrott bewahrte. Der Fotograf Mario Testino erinnert sich: „Anfang der 90er-Jahre rief mich Tom Ford wegen einer Kampagne für Gucci an. Carine (Roitfeld) und ich hatten einen bestimmten Stil für unsere Bilder, der seiner Meinung nach gut zu seinen Ideen für seinen neuen Posten als Kreativdirektor der Marke passte. Wir begaben uns auf eine wunderbare Reise, denn er war der erste gewerbliche Kunde, der uns nicht zurückhielt, sondern uns vorantrieb. Er wollte Bilder, die die Menschen dazu bringen, stehenzubleiben und hinzuschauen."

Trotz einiger höchst umstrittener Äußerungen, die seinem Ruf geschadet haben, kann niemand das kreative Genie von **John Galliano** (geb. 1960) leugnen. Nach seinem Studium am Central Saint Martins College Mitte der 1980er-Jahre und einem frühen Karrierestart in London zog Galliano 1989 nach Paris, wo er mit der enthusiastischen Unterstützung von Anna Wintour seinen Durchbruch als führender Modedesigner begann. Auf halbem Weg zwischen Salvador Dalí und Oscar Wilde ist der Geist, der in Gallianos Kollektionen spürbar ist, von dekadenter Opulenz und einem provokanten Sinn für Spott geprägt. Außerdem weist er Einflüsse aus der Französischen Revolution und dem Napoleonischen Reich auf. Er war der erste britische Designer, der die künstlerische Leitung einer französischen Marke übernahm. Er fing 1995 bei Givenchy und 1996 bei Dior an und verlieh den renommierten Häusern mit seinen extravaganten Kollektionen neuen Schwung.

The prodigious range of **Jean Paul Gaultier's** (b. 1952) collections and designs in the 1990s ensured him unrivalled media coverage and a reputation as fashion disrupter. From Madonna's conical corset to the costumes for Luc Besson's *The Fifth Element*, Gaultier constantly made headlines for his inventive creations taking classic elements of clothing to a futuristic level.

While **Tommy Hilfiger's** (b. 1951) designs are often called "new American classics" for their timeless elegance and preppy style, the rise of his brand over the 1990s was mainly due to his fans in the hip-hop scene, and the brand's endorsement by star rappers such as Snoop Dogg. Hilfiger's iconic jeans and underwear collections became staples of the hip-hop community.

Jean Paul Gaultiers (geb. 1952) Kollektionen und Entwürfe in den 1990er-Jahren sorgten für eine unvergleichliche Medienpräsenz bei seinen Schauen und sicherten ihm den Ruf eines Aufrührers der Modewelt. Von Madonnas konischem Korsett bis hin zu den Kostümen für Luc Bessons Film *Das fünfte Element* machte Gaultier immer wieder Schlagzeilen mit seinen originellen Kreationen, die klassische Kleidungselemente auf eine futuristische Ebene hoben.

Tommy Hilfigers (geb. 1951) Entwürfe werden aufgrund ihrer zeitlosen Eleganz und ihres Preppy Looks oft als "neue amerikanische Klassiker" bezeichnet. Der Aufstieg seiner Marke in den 1990er-Jahren ist jedoch vor allem auf seine Fans in der Hip-Hop-Szene und die Unterstützung der Marke durch berühmte Rapper wie Snoop Dogg zurückzuführen. Hilfigers kultige Kollektionen von Jeans und Unterwäsche waren besonders in der Hip-Hop-Community beliebt.

Page 82: Black lace blouse and pants by Tom Ford for Gucci, Spring 1996

Seite 82: Schwarze Spitzenbluse und Hose von Tom Ford für Gucci, Frühjahr 1996

Costumes designed by Jean Paul Gaultier for Luc Besson's blockbuster *The Fifth Element*, 1997

Von Jean Paul Gaultier entworfene Kostüme für Luc Bessons Blockbuster *Das fünfte Element*, 1997

Marc Jacobs (b. 1963) set the tone for the 1990s by launching the first ever grunge collection in 1992, for the Perry Ellis brand. The now iconic show triggered such outrage that it led to the designer's immediate firing. Jacobs subsequently founded his own fashion line, before taking over Louis Vuitton's creative direction in 1997 and breathing new life into the luxury brand.

After a successful decade in the sportswear world with the Anne Klein brand, New York born fashion designer **Donna Karan** (b. 1948) launched her first women's fashion collection in 1985, *Donna Karan New York*, as her high-fashion brand became to be known. It offered a set of seven "easy pieces", consisting of a skirt, a tailored jacket, a dress, something leather, a white shirt, a cashmere sweater, and was centred around a bodysuit, Karan's signature garment, which was a nod to her passion for yoga. These pieces could be easily mixed and matched to create various looks for active women for any occasion. Her simple, functional designs became the standard of NY elegance. Consecration came when First Lady Hillary Clinton wore a shoulder-baring DK dress at her first state dinner in 1993, soon followed by celebrities such as Catherine Zeta-Jones, Nicole Kidman, and future First Lady, Michelle Obama.

Advertising posters for **Calvin Klein's** (b. 1942) underwear collections and jeans have become milestones in commercial photography due to their raw sensuality. Klein's reinvention of the slip dress, which was confusingly similar to the original sexy sleepwear, propelled the designer to stratospheric success.

Modern glamour combined with a sporty look are at the core of **Michael Kors'** (b. 1959) vision of fashion, which he developed in the early 1990s under his own brand, before his appointment as creative director of Céline in 1997, bringing his American experience to a French high-fashion house.

Marc Jacobs (geb. 1963) gab den Ton für die 1990er-Jahre an, als er 1992 die erste Grunge-Kollektion für die Marke Perry Ellis herausbrachte. Die mittlerweile ikonische Show löste eine derartige Empörung aus, dass der Designer daraufhin sofort gefeuert wurde. Anschließend gründete Jacobs seine eigene Modelinie, bevor er 1997 die kreative Leitung von Louis Vuitton übernahm und der Luxusmarke neues Leben einhauchte.

Nach einem erfolgreichen Jahrzehnt in der Welt der Sportbekleidung mit der Marke Anne Klein brachte die in New York geborene Modedesignerin **Donna Karan** (geb. 1948) 1985 ihre erste Damenmodekollektion unter dem Label Donna Karan New York auf den Markt. Sie bot ein Set aus sieben einfachen Teilen an, das aus einem Rock, einer figurbetonten Jacke, einem Kleid, etwas aus Leder, einem weißen Hemd und einem Kaschmirpullover bestand. Im Mittelpunkt des Sets stand ein Body – Karans Markenzeichen, der eine Anspielung auf ihre Leidenschaft für Yoga war. Diese Teile ließen sich leicht kombinieren, um verschiedene Looks für aktive Frauen zu jedem Anlass zu kreieren.
Ihre schlichten, funktionalen Entwürfe wurden zum Maßstab für New Yorker Eleganz. Der Ritterschlag erfolgte, als First Lady Hillary Clinton 1993 bei ihrem ersten Staatsbankett ein schulterfreies DK-Kleid trug, dem bald darauf Prominente wie Catherine Zeta-Jones, Nicole Kidman und die künftige First Lady Michelle Obama folgten.

Die Werbeplakate für die Unterwäsche- und Jeanskollektionen von **Calvin Klein** (geb. 1942) sind aufgrund ihrer rohen Sinnlichkeit zu Meilensteinen der Werbefotografie geworden. Kleins Neuerfindung des Slipkleides, das dem ursprünglichen sexy Nachthemd zum Verwechseln ähnlich sah, verhalf dem Designer zu unglaublichem Erfolg.

Moderner Glamour in Kombination mit einem sportlichen Look sind der Kern von **Michael Kors** (geb. 1959) Vision von Mode, die er in den frühen 1990er-Jahren unter seiner eigenen Marke entwickelte, bevor er 1997 zum Kreativdirektor von Céline gemacht wurde und damit seine amerikanische Erfahrung in ein französisches High-Fashion-Haus einbrachte.

Model Carla Bruni and fashion designer Miuccia Prada at Prada's workshop, 1994

Model Carla Bruni und Modedesignerin Miuccia Prada in Pradas Studio, 1994

Fashions from the 1940s and flamboyant, Provençal-Mediterranean colours inspired **Christian Lacroix** (b. 1951) to create dreamy, highly feminine designs with a touch of nostalgia. Opulence met with vibrant hues that were also reminiscent of the late 18th century and Belle Époque. "When simplicity is fashionable, Christian Lacroix opts for exuberance; when black becomes the norm, he prefers blood red, fuchsia pink or bright yellow."

Thanks to **Helmut Lang** (b. 1956), minimalism transformed from its associations with austere, strict elegance to the ultimate chic, becoming a sophisticated version of unisex streetwear. The designer masterfully blended utilitarian minimalism with a sensual twist.

Die Mode der 1940er-Jahre und die extravaganten, provenzalisch-mediterranen Farben inspirierten **Christian Lacroix** (geb. 1951) zu verträumten und sehr femininen Entwürfen mit einem Hauch von Nostalgie. Opulenz traf auf leuchtende Farben, die auch an das späte 18. Jahrhundert und die Belle Époque erinnerten. „Wenn Schlichtheit in Mode ist, entscheidet sich Christian Lacroix für Überschwänglichkeit. Wenn Schwarz die Norm ist, bevorzugt er Blutrot, Fuchsia-Pink und leuchtendes Gelb."

Dank **Helmut Lang** (geb. 1956) wandelte sich der Minimalismus von seiner Assoziation mit strikter, strenger Eleganz zum ultimativen Chic und wurde zu einer raffinierten Version der Unisex-Streetwear. Der Designer hat es meisterhaft verstanden, utilitaristischen Minimalismus mit einer sinnlichen Note zu verbinden.

A rare picture of Belgian fashion designer Martin Margiela, New York, 1994

Ein seltenes Bild des belgischen Modedesigners Martin Margiela, New York, 1994

A key proponent of deconstruction in fashion, **Martin Margiela** (b. 1957) tirelessly broke prevailing industry rules with both his use of recycled materials and his refusal of the stardom status usually associated with fashion designers: he always remained backstage and rejected most of the requests for face-to-face interviews. His mysterious aura and the somewhat Dadaist-unconventional style of his designs made him a cult personality. By the end of the 1990s, he was appointed head of womenswear at Hermès.

Stella McCartney (b. 1971) trained in fashion design at Central St. Martins, where she graduated in 1995. Two years later, at the age of 26, she was appointed creative director of the French luxury brand Chloé, a position previously held by Karl Lagerfeld for thirty years. During her tenure, she designed Madonna's wedding dress in 2000. Stella McCartney has been one of the pioneers in sustainable and ethical fashion, using only animal-free fabrics for her designs since she started.

One of the most talented and influential fashion designers of the 1990s, **Alexander McQueen** (1969–2010) launched his first highly provocative collection, *Jack the Ripper Stalks His Victims*, upon graduating from Central St. Martins in 1992. A year later, *Taxi Driver*, his second show, saw the introduction of his iconic bumster trousers. The collection's name was a tribute to both Martin Scorsese's cult movie and to his own modest origins – McQueen's father was a London taxi driver. The designs themselves looked like a mix of historicism – he had trained as a classic tailor – and eccentric futurism. Despite a new, highly controversial collection in 1995, called *Highland Rape*, where models walked the runway in torn clothes, the designer was appointed by the prestigious French brand Givenchy to replace John Galliano in 1996.

Martin Margiela (geb. 1957), ein Hauptvertreter der Dekonstruktion in der Mode, brach unermüdlich mit den vorherrschenden Regeln der Branche, sowohl durch die Verwendung von recycelten Materialien als auch durch seine Weigerung, den normalerweise mit Modedesignern assoziierten Status eines Stars zu erlangen: Er blieb stets hinter der Bühne und lehnte die meisten Anfragen für persönliche Interviews ab. Seine geheimnisvolle Ausstrahlung und der etwas dadaistisch-unkonventionelle Stil seiner Entwürfe machten ihn zu einer Persönlichkeit mit Kultstatus. Ende der 1990er-Jahre wurde er zum Leiter der Damenmode bei Hermès berufen.

Stella McCartney (geb. 1971) absolvierte ihr Modedesignstudium am Central Saint Martins College, wo sie 1995 ihren Abschluss machte. Zwei Jahre später wurde sie im Alter von 26 Jahren als Kreativdirektorin bei der französischen Luxusmarke Chloé eingestellt – eine Position, die zuvor 30 Jahre lang von Karl Lagerfeld bekleidet wurde. Während ihrer Zeit dort entwarf sie im Jahr 2000 das Hochzeitskleid von Madonna. Stella McCartney gehört zu den Pionieren der nachhaltigen und ethischen Mode und verwendet seit ihren Anfängen nur tierfreie Stoffe für ihre Designs.

Alexander McQueen (1969–2010), einer der talentiertesten und einflussreichsten Modedesigner der 1990er-Jahre, präsentierte 1992 seine erste, höchst provokative Kollektion namens *Jack the Ripper Stalks His Victims* („Jack the Ripper stalkt seine Opfer") nach seinem Abschluss am Central Saint Martins College. Ein Jahr später führte er in *Taxi Driver*, seiner zweiten Show, seine kultigen Bumster Pants ein. Der Name der Kollektion war eine Hommage sowohl an Martin Scorseses Kultfilm als auch an seine eigene bescheidene Herkunft – McQueens Vater war Taxifahrer in London. Die Entwürfe selbst sahen aus wie eine Mischung aus Historismus (er hatte eine Ausbildung als klassischer Schneider absolviert) und exzentrischem Futurismus. Trotz einer neuen, höchst umstrittenen Kollektion von 1995 mit dem Titel *Highland Rape* („Highland-Vergewaltigung"), bei der die Models in zerrissenen Kleidern über den Laufsteg liefen, wurde der Designer 1996 von der renommierten französischen Marke Givenchy als Nachfolger von John Galliano eingestellt.

A NEW GENERATION OF FASHION DESIGNERS

A self-taught fashion designer with a background as ballet dancer and interior decorator, **Thierry Mugler** (1948–2022) marked the 1980s and 1990s with his colourful, sculptural designs that were perceived both as true artworks and pieces of clothing. He set the fashion scene ablaze with shows that took the boundaries of catwalk scenery to new heights and an aesthetic style that challenged minimalism and promoted unbridled exuberance.

With the launch of her iconic Vela nylon backpack, which marked a turning point in the history of a family brand associated with leather goods, **Miuccia Prada** (b. 1949) was already surprising the fashion world in the mid-1980s. She went on to create the high-fashion house Miu Miu in 1993, mixing and matching colours and materials in unconventional ways, a style that was later coined "ugly chic" and led her collections to cult status and rocketing sales. "Ugly is attractive, ugly is exciting. Maybe because it is newer," she stated in an interview, thus contributing to the rule-breaking philosophy that prevailed among young fashion designers in the 1990s. The names of her collections, such as *Banal Eccentricity* (Spring/Summer 1996), reflected this provocative approach "against the cliché of beauty, against the cliché of luxury".

Thierry Mugler (1948–2022), Autodidakt, Balletttänzer und Innenarchitekt, prägte die 1980er- und 1990er-Jahre mit seinen farbenfrohen, skulpturalen Entwürfen, die sowohl als Kunstwerke als auch als Kleidungsstücke wahrgenommen wurden. Er hat die Modeszene mit seinen Schauen, die mit den Regeln der Laufstegszenerie brachen, und mit seinem ästhetischen Stil, der den Minimalismus herausforderte und Überschwänglichkeit in ungezügelter Form zelebrierte, in Atem gehalten.

Bereits Mitte der 1980er-Jahre überraschte **Miuccia Prada** (geb. 1949) die Modewelt mit der Einführung ihres ikonischen Nylonrucksacks Vela, der einen Wendepunkt in der Geschichte einer mit Lederwaren assoziierten Familienmarke markierte.

French fashion designer Thierry Mugler surrounded by models at the end of his Spring 1999 haute couture show

Der französische Modedesigner Thierry Mugler, am Ende seiner Frühjahrs-Haute-Couture-Schau 1999 umgeben von Models

Page 90: Alexander McQueen's fashion show for Givenchy, Paris, 1999

Seite 90: Bei der Modenschau von Alexander McQueen für Givenchy, Paris 1999

Page 91: Model Stella Tenant at Givenchy's haute couture show by Alexander McQueen, Paris, 1997

Seite 91: Model Stella Tenant bei der Haute-Couture-Schau von Alexander McQueen für Givenchy, Paris 1997

At Christian Lacroix's haute couture show, Autumn 1999

Aus der Haute-Couture-Kollektion von Christian Lacroix, Herbst 1999

Page 95 top: Eccentric futurism as envisaged by Alexander McQueen for the Givenchy ready-to-wear collection, Autumn 1999

Seite 95 oben: Exzentrischer Futurismus im Stil von Alexander McQueen für die Givenchy, Prêt-à-porter-Schau, Herbst 1999

Page 95 bottom: Kate Moss at the Tommy Hilfiger fashion show, London, late 1990s

Seite 95 unten: Kate Moss bei der Tommy-Hilfiger-Modenschau, London, Ende der 1990er-Jahre

Jil Sander (b. 1943) had already gained recognition in the 1980s with a pure, minimalist style that went against the exuberant flow of the time. The 1990s were to prove the "queen of less" right, as her collections met women's aspirations for modernity, simplicity, and empowerment. She masterfully achieved the balance between sobriety, functionality, and elegance.

> "Initially, it was the unpractical in fashion that brought me to design my own line. I felt that it was much more attractive to cut clothes with respect for the living, three-dimensional body rather than to cover the body with decorative ideas. I studied proportions, fabrics and their properties, and I learned to master pattern making. My approach has always been rather sensual."
>
> Jil Sander, interview with the *New York Times*, June 2010

While training as a fashion designer for sportswear brands, **Anna Sui** (b. 1964) frequented the New York underground scene in the 1970s forging close relationships in the worlds of fashion, photography, art, music, and design. Thanks to her exceptionally multicultural background – Chinese, Japanese and French – Anna Sui invented designs that were both rooted in ancient traditions and decorative patterns as well as being in tune with the zeitgeist. With the support of Madonna, who wore one of her dresses at Paris Fashion Week in 1991, Anna Sui launched her own collection a couple of months later, in a style that fashion experts linked to Jean Paul Gaultier's and Thierry Mugler's fantastic universes.

With his unmistakable flamboyance, **Gianni Versace's** (1946–1997) designs reflected his focus on the luxury, excess, and voluptuousness of the 1990s. Leopard prints, extravagant colours, heavy gold jewellery and sequins contributed to creating an atmosphere of uninhibited, oversaturated luxury, in line with the backstage parties of the time. Nothing was too eccentric for Versace.

1993 gründete Prada die High-Fashion-Marke Miu Miu, für die sie Farben und Materialien auf unkonventionelle Art und Weise mischte und kombinierte – ein Stil, der später als Ugly Chic bezeichnet wurde und ihren Kollektionen zu Kultstatus und steigenden Verkaufszahlen verhalf. „Hässlich ist attraktiv, hässlich ist aufregend. Vielleicht, weil es neuer ist", sagte sie in einem Interview und trug damit zur Philosophie des Regelbrechens bei, die in den 1990er-Jahren unter jungen Modedesignern vorherrschte. Die Namen ihrer Kollektionen, wie *Banal Eccentricity* (Frühjahr/Sommer 1996), spiegeln diesen provokativen Ansatz „gegen das Klischee der Schönheit, gegen das Klischee des Luxus" wider.

Jil Sander (geb. 1943) hatte sich bereits in den 1980er-Jahren mit einem reinen, minimalistischen Stil einen Namen gemacht, der sich gegen die vorherrschende Strömung der Zeit richtete.

Die 1990er-Jahre sollten „the queen of less" Recht geben, denn ihre Kollektionen entsprachen dem Wunsch der Frauen nach Modernität, Schlichtheit und Empowerment. Sie schaffte meisterhaft die Balance zwischen Nüchternheit, Funktionalität und Eleganz.

„Ursprünglich war es das Unpraktische der Mode, das mich dazu brachte, meine eigene Linie zu entwerfen. Ich fand es viel attraktiver, Kleidung mit Respekt für den lebendigen, dreidimensionalen Körper zu schneidern, als den Körper mit dekorativen Ideen zu überziehen. Ich habe mich mit Proportionen, Stoffen und ihren Eigenschaften beschäftigt und gelernt, Muster zu entwerfen. Mein Ansatz war schon immer eher sinnlich."

Jil Sander im Interview mit der *New York Times*, Juni 2010

Während ihrer Ausbildung zur Modedesignerin für Sportbekleidungsmarken verkehrte **Anna Sui** (geb. 1964) in den 1970er-Jahren im New Yorker Untergrund und knüpfte enge Freundschaften zu Personen, die in den Bereichen Mode, Fotografie, Kunst, Musik und Design tätig waren. Dank ihres außergewöhnlich multikulturellen Hintergrunds – sie hat chinesische, japanische und französische Wurzeln – erfand Anna Sui Designs, die sowohl in alten Traditionen und dekorativen Mustern verwurzelt waren, als auch dem Zeitgeist entsprachen. Mit der Unterstützung von Madonna, die eines ihrer Kleider auf der Paris Fashion Week von 1991 trug, brachte Anna Sui einige Monate später ihre eigene Kollektion auf den Markt, deren Stil Modeexperten mit den fantastischen Universen von Jean Paul Gaultier und Thierry Mugler in Verbindung brachten.

Mit seiner unverwechselbaren Extravaganz spiegeln die Entwürfe von **Gianni Versace** (1946–1997) seinen Fokus auf den Luxus, den Exzess und die Wollust der 1990er-Jahre wider. Leopardendrucke, extravagante Farben, schwerer Goldschmuck und Pailletten trugen dazu bei, eine Atmosphäre von ungehemmtem, übersättigtem Luxus zu schaffen – ganz im Sinne der Backstage-Partys dieser Zeit. Für Versace war nichts zu exzentrisch.

Gianni Versace's fashion show, Paris, 1990

Bei der Modenschau von Gianni Versace, Paris, 1990

The rise of supermodels and fashion photographers

Until the 1980s, fashion models were mostly anonymous faces and figures whose status was closer to that of sandwich board men than to film and song celebrities. Even if some famous individuals, such as Lisa Fonssagrives, Twiggy, Uschi Obermaier and Peggy Moffitt, had already given a voice and a personality to the profession, their role remained, in the eyes of the public, that of living mannequins.

The rise of the supermodel arrived at the dawn of the 1980s, with half a dozen high-profile models filling the front pages of fashion magazines, talk shows, dance floors of the trendiest nightspots, the glamour pages of gossip magazines and tabloids throughout the 1990s: Cindy Crawford, Linda Evangelista, Naomi Campbell, Christy Turlington, Tatjana Patitz, and Kristen McMenamy, whose glamorous looks, supernatural grace and outrageous escapades were to eclipse the prominence once reserved for actresses, rock stars, and fashion designers.

The magnitude of their sudden wealth reflected an era when globalisation, the property boom and the nascent Internet offered prosperity that seemed limitless. The Big Six, as the media called them, were later joined by Kate Moss, whose size and proportions did not match the 'California Girl' standards that had been in place since the 1960s. Her androgynous appearance, her fragility and her reputation as an enfant terrible won the admiration of the public, who recognised in her Miss Everyone.

Kate Moss's name remains associated with the heroin chic era, when skinny, pale-skinned models with haggard, ringed eyes were all the rage and played in tune with the grunge style. In a completely different register, Claudia Schiffer embodied the osmosis between modelling and creative activities such as cinema and advertising which enabled her to become the highest paid supermodel in history. In the same vein, Carla Bruni, another supermodel of the 1990s, extended her career as a successful singer. The osmosis seems to be lasting as more and more singers and actresses also occasionally try their hand at modelling.

Supermodels Naomi Campbell and Kate Moss, London, 1999

Supermodels Naomi Campbell und Kate Moss, London, 1999

THE RISE OF SUPERMODELS AND FASHION PHOTOGRAPHERS

Gianni Versace and models at the end of his haute couture show, Los Angeles, 1991

Gianni Versace und Models am Ende seiner Modenschau, Los Angeles, 1991

Pages 102, 103: Supermodels Gisele Bündchen (left) and Naomi Campbell (right) at the Marc Jacobs fashion show, New York, 1994

Seiten 102, 103: Die Supermodels Gisele Bündchen (links) und Naomi Campbell (rechts) bei der Modenschau von Marc Jacobs, New York, 1994

THE RISE OF SUPERMODELS AND FASHION PHOTOGRAPHERS

101

THE RISE OF SUPERMODELS AND FASHION PHOTOGRAPHERS

103

Der Aufstieg der Supermodels und Modefotografen

Bis in die 1980er-Jahre waren Models meist anonyme Gesichter, deren Status eher dem einer wandelnden Werbetafel als dem von Filmschauspielerinnen und Sängerinnen entsprach. Auch wenn einige berühmte Persönlichkeiten wie Lisa Fonssagrives, Twiggy, Uschi Obermaier und Peggy Moffitt dem Beruf bereits eine Stimme und eine Persönlichkeit gegeben hatten, blieb ihre Rolle in den Augen der Öffentlichkeit die einer lebenden Schaufensterpuppe.

Der Aufstieg der Supermodels begann Anfang der 1980er-Jahre, als ein halbes Dutzend hochkarätiger Models die Titelseiten von Modemagazinen, Talkshows, die Tanzflächen der angesagtesten Clubs und die Glamourseiten von Klatschmagazinen und Boulevardzeitungen in den 1990er-Jahren füllten: Cindy Crawford, Linda Evangelista, Naomi Campbell, Christy Turlington, Tatjana Patitz und Kristen McMenamy, die mit ihrem glamourösen Aussehen, ihrer übernatürlichen Anmut und ihren unerhörten Eskapaden den Ruhm in den Schatten stellen sollten, der einst Schauspielerinnen, Rockstars und Modedesignern vorbehalten war.

Das Ausmaß ihres plötzlichen Reichtums spiegelt eine Ära wider, in der die Globalisierung, der Immobilienboom und das aufkommende Internet einen grenzenlos erscheinenden Wohlstand versprach. Zu den Big Six, wie sie von den Medien genannt wurden, gesellte sich später Kate Moss, deren Größe und Proportionen nicht den seit den 1960er-Jahren geltenden California-Girl-Maßen entsprachen. Ihre androgyne Erscheinung, ihre Zerbrechlichkeit und ihr Ruf als Enfant terrible brachten ihr die Bewunderung der Öffentlichkeit ein, die in ihr Miss Everyone sah.

Der Name Kate Moss wird nach wie vor mit der Ära des Heroin Chic in Verbindung gebracht, als dünne, blasse Models mit hageren, geröteten Augen der letzte Schrei waren und zum Grunge Style passten. In einem ganz anderen Bereich verkörperte Claudia Schiffer die Osmose zwischen dem Modeln und kreativen Tätigkeiten wie Film und Werbung, die es ihr ermöglichte, das bestbezahlte Supermodel der Geschichte zu werden. Auch Carla Bruni, ein weiteres Supermodel der 1990er-Jahre, baute ihre Karriere als erfolgreiche Sängerin aus. Die Osmose scheint nachhaltig zu sein, denn immer mehr Sängerinnen und Schauspielerinnen versuchen sich gelegentlich auch als Models.

Kate Moss photographed by Corinne Day for *Vogue*, March 1993

Kate Moss fotografiert von Corinne Day für *Vogue*, März 1993

Models Kate Moss, Naomi Campbell and Jodie Kidd with fashion designer Stella McCartney, October 1997

Die Models Kate Moss, Naomi Campbell und Jodie Kidd mit der Modedesignerin Stella McCartney, Oktober 1997

Pages 110-111: Backstage picture at the Marc Jacobs fashion show, New York, Spring 1997

Seiten 110-111: Backstage bei der Marc-Jacobs-Show, New York, Frühjahr 1997

Nadja Auermann, Carla Bruni, Naomi Campbell, Linda Evangelista, Claudia Schiffer and other top models at the Fashion Aid Clothing benefit within the Gianni Versace New Year show at the Ritz, Paris 1994

Nadja Auermann, Carla Bruni, Naomi Campbell, Linda Evangelista, Claudia Schiffer und andere Topmodels bei der Fashion-Aid-Clothing-Benefizveranstaltung im Rahmen der Gianni-Versace-Neujahrsschau im Ritz, Paris 1994

In the wake of the supermodels and young fashion designers, a new generation of fashion photographers also entered the scene. While, in the 1980s, fashion photography viewed models as living mannequins with no real expressivity and offered images of an ideal world far from everyday reality, photographers of the New Realism school, such as Wolfgang Tillmans, Juergen Teller and Terry Richardson, set out to photograph models in ordinary settings, sometimes even without make-up, deconsecrating their role as fashion priestesses and bringing them closer to real life.

Other photographers, such as Corinne Day, Mario Sorrenti and Ellen von Unwerth, offer a more elaborate staging, where the model's personality takes centre stage, with a provocative twist. Black and white is frequently favoured to emphasise contrast, particularly in the photographs of Steven Meisel and Bruce Weber, and above all in the work of Peter Lindbergh, whose mesmerising portraits of supermodels are inspired by the work of 20th-century photographic artists such as Dorothea Lange, Jacques-Henri Lartigue and Henri Cartier-Bresson who documented the life around them.

The avant-garde aesthetics of their pictures contributed to bringing the newly founded culture and fashion magazines such as *i-D* and *The Face* to the forefront and were quickly adopted by other media. In a completely different aesthetic spectrum, American photographer David LaChapelle won over the public with his dreamlike, surreal photographs in oversaturated colours. Mario Testino came to prominence in 1995 with a campaign for Versace featuring Madonna, who had insisted that he be commissioned. His photographs have since captured the luxury and decadence of fashion with a distinctly sensual edge.

Im Gefolge der Supermodels und jungen Modedesigner trat auch eine neue Generation von Modefotografen auf den Plan. Während die Modefotografie der 1980er-Jahre Models als lebende Schaufensterpuppen ohne wirkliche Ausdruckskraft betrachtet hatte und Bilder einer idealen Welt bot, die weit von der Alltagsrealität entfernt war, machten sich Fotografen des „Neuen Realismus" wie Wolfgang Tillmans, Juergen Teller und Terry Richardson daran, Models in gewöhnlichen Umgebungen zu fotografieren. Manchmal sogar ohne Make-up, um ihre Rolle als „Fashion-Priesterinnen" zu entzaubern und sie dem wirklichen Leben näher zu bringen.

Andere Fotografen wie Corinne Day, Mario Sorrenti oder Ellen von Unwerth entwarfen aufwändige Inszenierungen, bei der die Persönlichkeit des Modells im Mittelpunkt stand – stets mit einer Prise Provokation. Zur Betonung der Kontraste wurde häufig in schwarz-weiß fotografiert, vor allem von Steven Meisel und Bruce Weber, aber auch von Peter Lindbergh, dessen faszinierende Porträts von Supermodels von den Arbeiten berühmter Fotokünstler des 20. Jahrhunderts wie Dorothea Lange, Jacques-Henri Lartigue und Henri Cartier-Bresson inspiriert sind.

Die avantgardistische Ästhetik ihrer Bilder trug dazu bei, neu gegründete Kultur- und Modemagazine wie *i-D* und *The Face* bekannt zu machen und wurde schnell von anderen Medien übernommen. In einem anderen ästhetischen Spektrum eroberte der amerikanische Fotograf David LaChapelle mit seinen traumhaften, surrealen Fotografien in übersättigten Farben die Öffentlichkeit. Mario Testino wurde 1995 mit einer Kampagne für Versace mit Madonna bekannt, die darauf bestanden hatte, ihn zu beauftragen. Seine Fotografien fangen seitdem den Luxus und die Dekadenz der Mode mit einer ausgeprägt sinnlichen Note ein.

Page 109: Portrait and fashion photographer Mario Testino posing in front of his iconic portrait of Princess Diana

Seite 109: Porträt- und Modefotograf Mario Testino posiert vor seinem berühmten Porträt von Prinzessin Diana

THE RISE OF SUPERMODELS AND FASHION PHOTOGRAPHERS

THE RISE OF SUPERMODELS AND FASHION PHOTOGRAPHERS

Fashion in cult series and movies

When it comes to the influence of TV series on fashion in the 1990s, Jennifer Aniston and her *Friends* immediately come to mind.

There's the Rachel haircut, of course, but also some iconic Generation X outfits, such as the slip dress, the casual white tee and jeans combo (and more generally, any denim garment from overalls to jackets), checked shirts, monochrome clothing, sheer blouses and spaghetti strap tops. Friends also contributed to the popularization of the oversized and boyfriend styles. Rachel's glittering on-screen career in the fashion industry also gave considerable credence to the work of the series' stylists.

The same types of clothes are worn by the characters of *Beverly Hills 90210*, with the addition of crop tops and stronger references to the 1960s and preppy style, such as Donna's checkered blazer, which was quintessentially 90s. The series boosted the revival or launch of accessories such as the choker necklace, the scrunchie and claw clips. The film *Clueless* (1995) picked up on these sartorial codes while also introducing the plaid suit as an iconic outfit of the decade.

The white tee and jeans combo was the off-duty uniform of the 1990s

Die Kombination aus weißem T-Shirt und Jeans war die Freizeitkleidung der 1990er-Jahre

Rachel Green (Jennifer Aniston), of *Friends*, in one of her favourite outfits

Rachel Green (Jennifer Aniston) aus der Serie *Friends* in einem ihrer Lieblingsoutfits

The fashion stars of Beverly Hills 90210

Die Modestars von Beverly Hills 90210

Mode in Kultserien und –filmen

Wenn es um den Einfluss von Fernsehserien auf die Mode in den 1990er-Jahren geht, fallen einem sofort Jennifer Aniston und ihre *Friends* ein.

Der Rachel-Haarschnitt is natürlich besonders einprägsam, aber auch einige ikonische Outfits der Generation X, wie das Slipkleid, die lässige Kombination aus weißem T-Shirt und Jeans (bzw. einem Kleidungsstück aus Denim – vom Overall bis zur Jacke), karierte Hemden, einfarbige Kleidung, durchsichtige Blusen und Tops mit Spaghettiträgern. Die Serie *Friends* trug auch zur Popularisierung des Oversized Style und des Boyfriend Style bei. Rachels glamouröse Leinwandkarriere in der Modeindustrie hat auch die Arbeit der Stylisten der Serie maßgeblich beeinflusst.

Die gleiche Art von Kleidung trugen auch die Charaktere von *Beverly Hills 90210*. Allerdings ist deren Stil durch bauchfreie Tops, stärkere Verweise auf die 1960er-Jahre und den Preppy Style geprägt, wie Donnas karierter Blazer, der ganz im Zeichen der 90er-Jahre steht. Die Serie förderte die Wiederbelebung bzw. die Einführung von Accessoires wie Chokern, Haargummis und Haarspangen. Der Film *Clueless* (1995) griff diese Modetrends auf und machte den karierten Anzug zu einem der kultigsten Kleidungsstücke des Jahrzehnts.

Man würde nicht unbedingt behaupten, dass *Pulp Fiction* Trends in Sachen Mode gesetzt hätte, aber Uma Thurmans schlichte weiße Blusen, schwarze Hosen, ihr Bob und der Trenchcoat unterstrichen Mitte der 1990er-Jahre das Streben nach minimalistischer Eleganz, während *Kids* (1995) bahnbrechend für die Beliebtheit von Streetwear war.

Auch die Vinyl-, Leder- und Latex-Outfits, die Trinity (Carrie-Anne Moss) und andere Hauptfiguren in *The Matrix* (1999) tragen, haben die Mode nachhaltig beeinflusst: John Galliano gab zu, dass die Cyberpunk-Ästhetik des Films seine Herbstkollektion von 1999 inspiriert hat. In den 2000er-Jahren brachten Yohji Yamamoto und Tom Ford Kollektionen heraus, die sich direkt auf den Kultfilm und seine Fortsetzungen bezogen.

Cher Horowitz's unmistakable yellow plaid suit in *Clueless* (1995)

Cher Horowitz' unverwechselbarer gelbkarierter Anzug in *Clueless – Was sonst!* (1995)

One would not necessarily consider *Pulp Fiction* as a trend-setter in fashion, however, Uma Thurman's simple white button-ups, black pants, bob haircut, and trench coat emphasised the quest for minimalist elegance in the mid-1990s, while *Kids* (1995) proved seminal in the popularity of streetwear.

The vinyl, leather and latex outfits worn by Trinity (Carrie-Anne Moss) and other main characters of *The Matrix* (1999) also had a lasting influence on fashion: John Galliano admitted that the movie's cyberpunk aesthetics inspired his Fall 1999 collection. In the 2000s, Yohji Yamamoto and Tom Ford launched collections that directly referred to the cult movie and its sequels.

Uma Thurman as Mia Wallace, a fan of minimalist fashion, in *Pulp Fiction* (1994)

Uma Thurman als Mia Wallace, einem Fan von minimalistischer Mode, in *Pulp Fiction* (1994)

Page 119: The futuristic costumes of *The Matrix* (1999) inspired many fashion designers

Seite 119: Die futuristischen Kostüme von *Matrix* (1999) inspirierten viele Modedesigner

FASHION IN CULT SERIES AND MOVIES

In the beginning there was MTV

Diverse and highly eclectic, the music of the 1990s eludes easy categorisation. However, it has left a lasting legacy by exploring the boundaries of sound and inspiring most of the fashion trends of the time, such as hip-hop, grunge, casual streetwear, and minimalism.

Female singers such as Madonna, Courtney Love and Aaliyah have come to embody some of the iconic styles of the 1990s. As music journalist Sarah Osei put it "Daringly androgynous and sexy at once, with boyish swagger and street sensibility, Aaliyah set the stage for the Rihannas, Kendall Jenners, and Jorja Smiths of the subsequent years. Whether you're sporting your Calvin's, oversized leather jackets, or like your jeans real baggy, best believe Aaliyah has informed some part of your fashion identity."

After a modest start at its launch in 1981 and a focus on youth culture, MTV gained considerable influence by the mid-second half of the 90s and had a strong impact on the development of music videos. From then on, it was not just the music that made a given single popular, but also the visual staging of the video clip, in which stylists played an essential role.

The MTV Video Music Awards, launched in 1984 as an alternative to the more traditional Grammy Awards, increasing in popularity through the 1990s, with stars such as Madonna, Prince, Kurt Cobain and Courtney Love, Snoop Dogg, Michael Jackson and the Spice Girls performing live. The MTV Awards evening was a great opportunity for celebrities to show off in extravagant outfits, liberated from dress codes expected at other social events. In 1998, Gwen Stefani showed up in a faux-fur, bright-blue bikini top (with her hair dyed to match) paired with a black, futuristic skirt over pants (a trend in the late 1990s) and platform sandals, while Rose McGowan opted for a transparent dress with merely a thong underneath and high heels. Although the more classically styled Gwyneth Paltrow used the MTV ceremony to debut her iconic velour suit with a daring décolleté.

Gwyneth Paltrow in her iconic velour suit, MTV Video Music Awards, 1996

Gwyneth Paltrow in ihrem ikonischen Veloursanzug, MTV Video Music Awards, 1996

The Spice Girls at the MTV Europe Music Awards, 1997

Die Spice Girls bei den MTV Europe Music Awards, 1997

Gwen Stefani, Melissa Gaboriau Auf der Maur and Courtney Love at the MTV Video Music Awards, 1998

Gwen Stefani, Melissa Gaboriau Auf der Maur und Courtney Love bei den MTV Video Music Awards, 1998

Die goldene Zeit von MTV

Die Musik der 1990er-Jahre ist sehr vielfältig und eklektisch, daher lässt sie sich nicht so leicht kategorisieren. Ihr Einfluss ist jedoch von Dauer, da sie mit neuen Sounds die Kunstform bereichert und die meisten Modetrends dieser Zeit, wie Hip-Hop, Grunge, lässige Streetwear und Minimalismus, inspiriert hat.

Sängerinnen wie Madonna, Courtney Love und Aaliyah verkörpern einige der kultigsten Stile der 1990er-Jahre. Die Musikjournalistin Sarah Osei hat ihren Einfluss folgendermaßen beschrieben: „Mit ihrem gewagt androgynen, aber sexy Look, ihrem jungenhaften Auftreten und ihrer Straßenaffinität hat Aaliyah den Weg für die Rihannas, Kendall Jenners und Jorja Smiths der nachfolgenden Jahre bereitet. Egal, ob du deine übergroße Lederjacke von Calvin oder eine richtige Baggy-Jeans trägst, du kannst davon ausgehen, dass Aaliyah einen Teil deiner modischen Identität geprägt hat."

Nach einem bescheidenen Start im Jahr 1981, bei dem der Fokus auf der Jugendkultur lag, gewann MTV Mitte der zweiten Hälfte der 90er-Jahre beträchtlichen Einfluss, was sich stark auf die Produktion von Musikvideos auswirkte. Von nun an war es nicht mehr nur die Musik, die eine bestimmte Single populär machte, sondern auch die visuelle Inszenierung des Musikvideos, bei dem Stylisten eine wesentliche Rolle spielten.

Die MTV Video Music Awards, die 1984 als Alternative zu den traditionellen Grammy Awards ins Leben gerufen wurden, erfreuten sich in den 1990er-Jahren zunehmender Beliebtheit, wobei Stars wie Madonna, Prince, Kurt Cobain und Courtney Love, Snoop Dogg, Michael Jackson und die Spice Girls live auftraten. Die Show von MTV bot Prominenten eine großartige Gelegenheit, sich in extravaganten Outfits zu zeigen – losgelöst von der Kleiderordnung, die bei anderen gesellschaftlichen Veranstaltungen galt. Gwen Stefani zeigte sich 1998 in einem hellblauen Bikinioberteil aus Kunstpelz (mit passend gefärbten Haaren) mit einem schwarzen, futuristischen Rock über ihrer Hose (ein Trend in den späten 1990er-Jahren) und Plateausandalen, während Rose McGowan sich für ein transparentes Kleid mit lediglich einem Tanga darunter und High Heels entschied. Die eher klassisch gestylte Gwyneth Paltrow hingegen nutzte die Preisverleihung, um ihren ikonischen Veloursanzug mit gewagtem Ausschnitt zu präsentieren.

Madonna performing "Vogue" at the MTV Video Music Awards, Los Angeles, 1990

Madonna singt „Vogue" bei den MTV Video Music Awards, Los Angeles, 1990

A fashion icon of the 1990s: Lady Diana (1961–1997)

While Princess Diana may have appeared self-effacing and shy in the early 1980s as she tried to conform to the customs and traditions of the Royal Family and the role she was assigned, the unravelling of her marriage to Prince Charles, in the early 1990s prompted Diana to break free of the shackles and reveal her real personality. Princess Diana's stature (5' 10", which meant she was as tall as her ex-husband, the current King Charles III), meant she could easily have been a model according to the canons of the time and she had a slender elegance that allowed her to shine in any outfit.

Princess Diana in a turquoise silk dress by Versace, Sydney, 1996

Prinzessin Diana in einem türkisfarbenen Seidenkleid von Versace, Sydney, 1996

Princess Diana in a red dress, Buenos Aires, Argentina, 1995

Prinzessin Diana in einem roten Kleid, Buenos Aires, Argentinien, 1995

Page 129: Princess Diana in a classic houndstooth-pattern red-and-black suit, Sandringham, Christmas 1990

Seite 129: Prinzessin Diana in einem klassischen, rot-schwarzen Anzug mit Hahnentrittmuster, Sandringham, Weihnachten 1990

Eine Modeikone der 1990er-Jahre: Lady Diana (1961–1997)

Während Prinzessin Diana in den frühen 1980er-Jahren zurückhaltend und schüchtern wirkte, weil sie versuchte, sich den Sitten und Gebräuchen der königlichen Familie und der ihr zugewiesenen Rolle anzupassen, veranlasste das Scheitern ihrer Ehe mit Prinz Charles in den frühen 1990er-Jahren Diana dazu, sich von den Fesseln zu befreien und ihre wahre Persönlichkeit zu offenbaren. Aufgrund ihrer Statur (mit 1,78 Metern war sie so groß wie ihr Ex-Mann, der heutige König Charles III.) hätte Prinzessin Diana nach den damaligen Maßstäben ohne Weiteres ein Model sein können. Sie verfügte auch über eine schlanke, elegante Erscheinung, die sie in jedem Outfit bezaubernd erscheinen ließ.

Princess Diana wearing a slip dress designed by John Galliano, Costume Institute Ball, MET New York, 1996

Prinzessin Diana trägt ein von John Galliano entworfenes Slipkleid, Costume Institute Ball, MET New York 1996

EINE MODEIKONE DER 1990ER-JAHRE: LADY DIANA (1961-1997)

The famous "Revenge dress" is one of her best-known gowns from this period. Designed by Christina Stambolian, this off-the-shoulder dress, with its asymmetrical hemline above the knee, had been in Diana's wardrobe for three years before she decided to wear it to the summer party at the Serpentine Gallery on June 29th, 1994. On the same day, Prince Charles made his first public admission of infidelity to his wife. However, Diana's dashing appearance in this exquisitely tailored dress overshadowed the princely confession: she made the headlines, which reflected the garment's jaw-dropping effect – and the unfaithful husband earned some mocking comments ("The Thrilla He Left To Woo Camilla," *The Sun* wrote).

While continuing to wear highly elaborate dresses designed by her favourite designer, Frenchwoman Catherine Walker, Princess Diana also reflected the dress codes of modern women, in particular the blazer-blouse-Capri pants combo, and she was also seen in sportswear, including bike shorts, ski suits and swimming suits. This love of sportswear matched her athletic, active nature and perfectly echoed the fashion for athleisure.

Lady Diana was the first member of the "Firm" to wear jeans (or at least the first one to do so in public), which was a way of ridiculing the other Royals with their stuffy, old-fashioned image. Even for formal events, such as the MET Gala in New York, in December 1996, Princess Diana was able to cause quite a buzz with a fashionable gown that showed off her figure to best advantage: designed by John Galliano, by then at Christian Dior, the dark blue dress was none else than an elongated, dark-blue slip dress made of silk, as if she were embodying the Sleeping Beauty. The dress was so avant-garde that only few people were paying attention to the beautiful necklace with a sapphire offered by the Queen Mum on the occasion of Diana's wedding sixteen years before.

Princess Diana in her legendary "Revenge dress" designed by Christina Stambolian, Serpentine Gallery, June 1994

Prinzessin Diana in ihrem legendären, von Christina Stambolian entworfenen „Rachekleid", Serpentine Gallery, Juni 1994

134

Das berühmte Rachekleid ist eines ihrer bekanntesten Kleider aus dieser Zeit. Das von Christina Stambolian entworfene schulterfreie Kleid mit seinem asymmetrischen Saum oberhalb des Knies befand sich bereits seit drei Jahren in Dianas Kleiderschrank, bevor sie sich entschloss, es am 29. Juni 1994 zum Sommerfest in der Serpentine Gallery zu tragen. Am selben Tag gab Prinz Charles erstmals öffentlich zu, dass er seiner Frau nicht treu war. Dianas eleganter Auftritt in diesem exquisit geschneiderten Kleid überschattete jedoch die Beichte des Thronfolgers. Sie machte Schlagzeilen aufgrund der umwerfenden Wirkung des Kleidungsstücks, während ihr untreuer Ehemann einige spöttische Kommentare von der Presse erntete.

Prinzessin Diana trug zwar weiterhin sehr aufwendige Kleider ihrer Lieblingsdesignerin, der Französin Catherine Walker, doch spiegelte sie auch die Kleiderordnung der modernen Frau wider, besonders in der Kombination Blazer-Bluse-Caprihose. Man sah sie auch in Sportbekleidung, darunter Radlerhosen, Skianzüge und Badeanzüge. Diese Vorliebe für Sportbekleidung passte zu ihrem sportlich-aktiven Wesen. Der Athleisure Style wurde von ihr in Perfektion getragen.

Lady Diana war das erste Mitglied des Königshauses das Jeans trug (oder zumindest das erste, das dies in der Öffentlichkeit tat), was eine Möglichkeit war, die anderen Royals mit ihrem spießigen, altmodischen Image lächerlich zu machen. Auch bei formellen Anlässen wie der MET-Gala in New York im Dezember 1996 konnte Prinzessin Diana mit einem modischen Kleid, das ihre Figur optimal zur Geltung brachte, für Aufsehen sorgen: Das von John Galliano, der damals bei Christian Dior tätig war, entworfene dunkelblaues Kleid war nichts anderes als ein langgezogenes, dunkelblaues Unterkleid aus Seide. Sie wirkte damit, als würde sie Dornröschen verkörpern. Das Kleid war so avantgardistisch, dass nur wenige auf die wunderschöne Saphirhalskette achteten, die die Queen Mum Diana 16 Jahre zuvor anlässlich ihrer Hochzeit geschenkt hatte.

A military-style suit designed by Catherine Walker

Ein von Catherine Walker entworfener Anzug im Militärstil

Page 136: Princess Diana's iconic blazer-blouse-jeans combo, 1993

Seite 136: Prinzessin Dianas typische Kombination aus Blazer, Bluse und Jeans, 1993

Page 137: Princess Diana, London, 1997

Seite 137: Prinzessin Diana, London, 1997

A FASHION ICON OF THE 1990s: LADY DIANA (1961-1997)

The quintessential pieces of clothing from the 1990s

Die unverzichtbaren Kleidungsstücke aus den 1990er-Jahren

Baby tees

In stark contrast to the oversized trend that dominated the 1990s, the baby tee is a shrunken-down version of the regular t-shirt, but with a touch of softness that was inspired by French-cut tops made of cotton rib knit fabric, a garment that was popular in the 1970s and fell out of fashion in the early 1980s. Linda Meltzer, a LA-based stylist for music videos and movies, had a passion for these vintage tees, but was unable to find any in second-hand shops. So she decided to launch her own collection of fitted tees, which she called Tease tees, in 1993. Serendipity led Meltzer to Fred Segal, which was a seminal clothing brand by the time, and a hotspot for Hollywood stylists. Soon afterwards, Jennifer Aniston showed up in one of Meltzer's baby tees in *Friends*. They were also spotted on Kate Moss, Elle Macpherson, Claudia Schiffer, Drew Barrymore, and countless teenagers who paired them with low-rise flared jeans and miniskirts.

Baby Tees

Im Gegensatz zu dem in den 1990er-Jahren vorherrschenden Oversize-Trend ist das Baby Tee eine verkleinerte Version des normalen T-Shirts, aber mit einem Hauch von Geschmeidigkeit, inspiriert von französisch geschnittenen Oberteilen aus Baumwoll-Rippstrick, die in den 1970er-Jahren beliebt waren und Anfang der 1980er-Jahre aus der Mode kamen. Linda Meltzer, eine in Los Angeles ansässige Stylistin für Musikvideos und Filme, hatte eine Leidenschaft für diese Vintage-T-Shirts, konnte aber in Second-Hand-Läden keine finden. So beschloss sie 1993, ihre eigene Kollektion von taillierten T-Shirts auf den Markt zu bringen, die sie Tease Tees nannte. Ein glücklicher Zufall führte Meltzer zu Fred Segal, einer zu dieser Zeit wegweisenden Bekleidungsmarke und einem Hotspot für Hollywood-Stylisten. Bald darauf tauchte Jennifer Aniston in *Friends* in einem von Meltzers Baby-T-Shirts auf. Sie wurden auch von Kate Moss, Elle Macpherson, Claudia Schiffer, Drew Barrymore und unzähligen Teenagern getragen, kombiniert mit tiefsitzenden Röhrenjeans und Miniröcken.

Pages 142-143: Supermodel Claudia Schiffer in one of her signature baby tees, Paris, 1995

Seiten 142-143: Supermodel Claudia Schiffer in einem ihrer typischen Baby-T-Shirts, Paris, 1995

THE QUINTESSENTIAL PIECES OF CLOTHING FROM THE 1990s

143

Baby doll dresses

The baby doll dress of the 1990s is a surprising mixture of two influences. One of these was the American nightgown of the 1940s, designed at a time of fabric shortages resulting in shorter, sleeveless, and translucent models. The other was the minidress of the 1960s, with its typical trapezoid shape that gave the wearers a quirky, little girl look. While both previous garments fiddled with dress codes to give young, emancipated women a falsely innocent style, for the grunge icons of the 1990s such as Courtney Love and Kat Bjelland wearing a baby doll dress conveyed a message that was more contentious and subversive: it was a deliberate stance against the infantilisation of women, a rejection of the neat-and-tidy notion traditionally associated with feminine beauty. The standard *kinderwhore* look, as it came to be known, consisted of ripped fishnet tights or woollen knee-socks, a baby doll dress with a Peter Pan collar, combat shoes, messy hair, and excessive make-up that emphasised the good-girl-gone-bad style, halfway between Nabokov's Lolita and Manga heroines.

Courtney Love in a baby doll dress, 1994

BabydollKleider

Das Babydoll-Kleid der 1990er-Jahre ist eine erstaunliche Mischung zweier Trends. Der eine war das amerikanische Nachthemd der 1940er-Jahre, entworfen in einer Zeit der Stoffknappheit, was zu kürzeren, ärmellosen und durchsichtigen Modellen führte. Der andere war das Minikleid der 1960er-Jahre mit seiner typischen Trapezform, die den Trägerinnen einen schrulligen Mädchenlook verlieh. Während die beiden vorherigen Modelle mit der Kleiderordnung spielten, um jungen, emanzipierten Frauen einen scheinbar unschuldigen Stil zu verleihen, vermittelte das Tragen eines Babydoll-Kleides für die Grunge-Ikonen der 1990er wie Courtney Love und Kat Bjelland eine Botschaft, die noch umstrittener und subversiver war: Es war eine bewusste Stellungnahme gegen die Infantilisierung der Frau, eine Ablehnung der traditionell mit weiblicher Schönheit assoziierten Vorstellung von Sauberkeit und Ordnung. Der klassische „Kinderwhore"-Look bestand aus zerrissenen Netzstrumpfhosen oder Wollkniestrümpfen, einem Babydoll-Kleid mit Peter-Pan-Kragen, Springerstiefeln, unordentlichem Haar und übertriebenem Make-up, das den Stil des braven Mädchens betonte, auf halbem Weg zwischen Nabokovs Lolita und Manga-Heldinnen.

Courtney Love in einem Babydoll-Kleid, 1994

Baggy jeans

A true invention of the 1990s, baggy jeans revolutionised the aesthetics of denim trousers, which had been characterised by the prevailing straight cut of the iconic Levi's 501s, although the fashion for bell-bottoms in the 1970s had already challenged that aesthetic. Probably inspired by the wide leg track pants that were popular among joggers in the 1980s, baggy jeans emerged in the early 1990s in the hip-hop and skate communities, where the freedom of movement it offered was highly valued, as was the "inmate" look it was supposed to confer – incarcerated people in the United States were often given trousers with an elastic waistband instead of a belt, and these pants were generally too wide. Baggy jeans quickly moved from street fashion to the catwalks and cult movies such as *Kids* by Larry Clark (1995), making them the ultimate cool garment of the time. Although they were replaced by the slim fit around the end of the decade, baggy jeans have resurfaced several times since the beginning of the new millennium.

Baggy Jeans

Die Baggy-Jeans, eine echte Erfindung der 1990er-Jahre, revolutionierte die Form der Jeanshosen, die bis dahin durch den vorherrschenden geraden Schnitt der legendären Levi's 501 geprägt war, obwohl die Mode der Schlaghosen in den 1970er-Jahren diese Ästhetik bereits in Frage gestellt hatte. Vermutlich inspiriert von den weit geschnittenen Jogginghosen, die in den 1980er-Jahren bei Joggern beliebt waren, kamen Baggy-Jeans in den frühen 1990ern in der Hip-Hop- und Skate-Szene auf. Die Bewegungsfreiheit, die sie boten, waren beliebt, ebenso wie der „Häftlingslook", den sie vermittelten: Inhaftierte in den USA trugen oft Hosen mit einem elastischen Bund statt eines Gürtels, und diese Hosen waren im Allgemeinen zu weit. Baggy-Jeans eroberten schnell die Straßen, die Laufstege und Kultfilme wie *Kids* von Larry Clark (1995) und wurden so zum ultimativ coolen Kleidungsstück der Zeit. Obwohl sie gegen Ende des Jahrzehnts von der Slim-Fit-Passform abgelöst wurden, sind Baggy-Jeans seit Beginn des neuen Jahrtausends immer wieder in Erscheinung getreten.

THE QUINTESSENTIAL PIECES OF CLOTHING FROM THE 1990s

147

THE QUINTESSENTIAL PIECES OF CLOTHING FROM THE 1990s

Bike shorts

Bike shorts were already famous in the 1980s as casual sportswear. For example, Lady Diana was regularly shown in tabloids and gossip magazines wearing them, paired with oversized sweatshirts and sneakers, after gym sessions. However, they were not yet accepted as an obvious choice for everyday clothing until the 1990s, when comfort and function were placed first, thus paving the way to the rise of athleisure. True, Demi Moore had made headlines at the Oscars in 1989 wearing a chic version of spandex bike shorts she had fashioned herself, together with a corset and a fairy-tale cloak, the media reported that her outfit was, at best, something experimental. Five years on, and the fashion-conscious main characters of *Clueless*, Cher and Dionne, would sport bike shorts to emphasize their fit figures. Bike shorts made the ideal companion to crop tops and tube tops, two iconic pieces en vogue in the 1990s. Nowadays, the use of bike shorts also serves to show off a woman's curves, as shown by celebrities such as Kim Kardashian and Kylie Jenner.

Radlerhosen

Radlerhosen waren bereits in den 1980er-Jahren als lässige Sportbekleidung bekannt. Lady Diana beispielsweise war regelmäßig in Boulevard- und Klatschmagazinen zu sehen, wie sie sie in Kombination mit übergroßen Sweatshirts und Turnschuhen trug. Als Alltagskleidung wurden sie jedoch erst in den 1990er-Jahren akzeptiert, als Komfort und Funktion an erster Stelle standen und damit der Weg für den Aufstieg von Athleisure Wear frei war. Zwar machte Demi Moore 1989 bei der Oscar-Verleihung Schlagzeilen, als sie eine selbst genähte Elasthan-Radlerhose mit einem Korsett und einem feenhaften Umhang kombinierte, doch die Medien hielten ihr Outfit damals bestenfalls für experimentell. Fünf Jahre später trugen auch die modebewussten Hauptdarstellerinnen von *Clueless*, Cher und Dionne, Radlerhosen, um ihre durchtrainierten Figuren zu betonen. Radlerhosen waren die ideale Ergänzung zu Crop Tops und Tube Tops, zwei ikonischen Kleidungsstücken, die in den 1990er-Jahren en vogue waren. Heutzutage dienen Radlerhosen auch dazu, die Kurven einer Frau zu betonen, wie Kim Kardashian und Kylie Jenner zeigen.

THE QUINTESSENTIAL PIECES OF CLOTHING FROM THE 1990s

151

Bomber jackets

The history of the bomber jacket is closely tied to that of military aviation, as the first jackets were designed for American pilots who were involved in air battles over Europe during WWI and needed warm clothes to protect them from the cold winds in their open cockpits. Just like the trench coat, another piece of the military uniform that became civilian clothing, the bomber jacket became fashionable as masculine outerwear in the early 1950s, when some iconic models were spotted on Hollywood stars such as James Dean, Humphrey Bogart, and Marlon Brando. While touring in Korea to support US troops stationed there in 1954, Marilyn Monroe was photographed wearing a B-15 jacket, thus endorsing it as a garment for the modern woman. Its renewed popularity in the 1990s owes a lot to *Top Gun*'s duo, Kelly McGillis and Tom Cruise, who took the leather flight jacket to a new level of elegance. Celebrities of the time paired it with leggings, ripped jeans, slip dresses, or crop tops.

Bomberjacken

Die Geschichte der Bomberjacke ist eng mit der Geschichte der militärischen Luftfahrt verbunden, denn die ersten Jacken wurden für amerikanische Piloten entworfen, die während des Ersten Weltkriegs an Luftkämpfen über Europa teilnahmen. Sie benötigten warme Kleidung, um sich vor den kalten Winden in ihren offenen Cockpits zu schützen. Genau wie der Trenchcoat, ebenfalls ein Teil der Militäruniform, das zur Zivilkleidung wurde, kam die Bomberjacke in den frühen 1950ern als männliche Oberbekleidung in Mode, als einige ikonische Modelle an Hollywood-Stars wie James Dean, Humphrey Bogart und Marlon Brando zu sehen waren. Als Marilyn Monroe 1954 in Korea auf Truppenbesuch war, wurde sie in einer B-15-Jacke abgelichtet, wodurch die Bomberjacke zu einem Kleidungsstück für moderne Frauen wurde. Ihre erneute Popularität in den 1990er-Jahren verdankt sie dem *Top-Gun*-Duo Kelly McGillis und Tom Cruise, die der Leather-Flight-Jacke eine neue Eleganz verliehen. Die Prominenten dieser Zeit kombinierten sie mit Leggings, Ripped Jeans, Slip Dresses oder Crop Tops.

Actress Kelly McGillis wearing a bomber jacket in *Top Gun*, 1986

Die Schauspielerin Kelly McGillis trägt eine Bomberjacke in *Top Gun*, 1986

THE QUINTESSENTIAL PIECES OF CLOTHING FROM THE 1990s

155

Cargo Pants

Nothing utilitarian and functional has really slipped through the cracks of 1990s fashion, witness the rise of cargo pants from its role as part of army field uniform to its adoption as a staple for the urban woman. For "cargo pants" is actually the civilian name of the combat pants, which were introduced as part of the battlefield dress of the British army as early as 1938.

It differed from the traditional khaki pants by the addition of two large, square-shaped pockets on the outer side of each leg, called cargo legs, which allowed the storage of bigger items that would not fit into front or back pockets. It was adopted by other armies in the course of WWII and made widely available as workwear for the building industry and was available as leisurewear for hikers through army surplus outlets.

Some hip-hop dancers chose them as their performance garment in the early 1990's, because of their proven robustness and the freedom of movement they provided, similar to that of baggy jeans. It took just a couple of years more to see cargo pants on the catwalks, with softer fabrics and more vivid colours on offer – Ralph Lauren launched silk cargo pants in his winter 1998 collection. Meanwhile, cargo pockets were added to jeans, shorts, and even capri pants.

Cargohosen

Die Mode der 1990er-Jahre hat kaum etwas Funktionaleres hervorgebracht als die Cargohose. Als Teil der Felduniform der Armee erlebte sie einen sagenhaften Aufstieg hin zur Grundausstattung für jede moderne Frau. Denn „Cargo Pants" ist eigentlich die zivile Bezeichnung für Kampfhosen, die bereits 1938 als Teil der Feldbekleidung der britischen Armee eingeführt wurden.

Sie unterschieden sich von der traditionellen Khakihose durch zwei große, quadratische Taschen an der Außenseite jedes Beins, die sogenannten Cargobeine, in denen man größere Gegenstände verstauen konnte, die nicht in die Vorder- oder Gesäßtaschen passten. Sie wurde im Laufe des Zweiten Weltkriegs von anderen Armeen übernommen und als Arbeitskleidung für das Baugewerbe und Freizeitkleidung für Wanderer in Army Outlets angeboten.

Einige Hip-Hop-Tänzer wählten sie in den frühen 1990er-Jahren als Performance-Kleidungsstück, da sie sich als robust erwiesen und eine ähnliche Bewegungsfreiheit wie Baggy Jeans boten. Es dauerte nur noch ein paar Jahre, bis Cargohosen auf den Laufstegen zu sehen waren, mit weicheren Stoffen und lebhafteren Farben. Ralph Lauren führte in seiner Winterkollektion 1998 Cargohosen aus Seide ein. In der Zwischenzeit wurden Cargotaschen an Jeans, Shorts und sogar Caprihosen angebracht.

Coogi sweaters

Inspired by indigenous Australian decorative patterns, the first Cuggi multicoloured sweaters were launched in the early 1970s and may have remained an only local success if not for Brooklyn-based rap singers such as the Notorious B.I.G, who adopted the sweater with its coloured patterns as their signature style, along with a beret and a pair of sunglasses. By that time, Cuggi was rebranded as "Coogi", to sound more authentically Australian – like Kangol, another famous Aussie label of bucket hats and berets hailed by the hip-hop community. True, the sweaters were initially designed for men, but they were unisex enough to also appeal to women. What made the Coogi knitwear so popular with the rap scene? The kaleidoscopic effect of the patterns and the bold palette of colours, certainly, as well as the particular comfort provided by the mix of wool and cotton, plus the fact that it can be worn in various styles, from casual to dressy.

Coogi-Pullover

Inspiriert von den dekorativen Mustern der australischen Ureinwohner kamen die ersten bunten Cuggi-Pullover Anfang der 1970er-Jahre auf den Markt und wären vielleicht nur ein lokaler Erfolg geblieben, wenn nicht in Brooklyn lebende Rap-Sänger wie Notorious B.I.G. den Pullover mit seinen bunten Mustern zu ihrem Markenzeichen gemacht hätten, zusammen mit einer Baskenmütze und einer Sonnenbrille. Zu dieser Zeit wurde Cuggi in „Coogi" umbenannt, um authentischer nach Australien zu klingen – wie Kangol, ein anderes berühmtes australisches Label für Schieber- und Baskenmützen, das von der Hip-Hop-Community gefeiert wurde. Zwar wurden die Pullover ursprünglich für Männer entworfen, aber sie waren unisex genug, um auch Frauen anzusprechen. Was machte die Strickteile von Coogi in der Rap-Szene so beliebt? Sicherlich der kaleidoskopische Effekt der Muster und die kräftige Farbpalette. Aber auch der besondere Komfort, den die Mischung aus Wolle und Baumwolle bietet, sowie die Tatsache, dass man sie in verschiedenen Stilen tragen kann: von lässig bis schick.

Corset tops

When French fashion designer Jean Paul Gaultier put Madonna in a pink satin corset for her *Blond Ambition* world tour in 1990, he was paying tribute to a tradition of burlesque and cabaret that had looked somewhat passé at the time. However, Madonna's performances in her provocative corset, whose design also referred to the conical bras of the 1950s, was enthusiastically applauded by the crowds due to this underwear's ability to give the torso ideal, highly feminine proportions. Shortly afterwards, Vivienne Westwood revisited the classical 18th century corset in her *Portrait* Collection. Unlike in the 19th century, when women suffered from the corset's inevitable pressure on the ribs, the hips, and the lungs, modern components gave the corset all the required flexibility.

The corset was now worn as regular outerwear, paired with low-rise jeans, a leather skirt, or baggy pants, and sometimes layered over a white t-shirt. Additionally, the corset found staunch supporters among fetishists and fans of BDSM, who saw it as the symbol of the dominant, emancipated woman, thus completely transforming the perception of the corset, which had been rejected in the 1910s by the first feminists due to the physical constraints it imposed on women.

Madonna wearing her cult corset designed by Jean Paul Gaultier, 1990

Madonna in ihrem von Jean Paul Gaultier entworfenen Kult-Korsett, 1990

Korsett – Oberteile

Als der französische Modedesigner Jean Paul Gaultier 1990 Madonna für ihre Welttournee *Blond Ambition* in ein rosa Satinkorsett steckte, zollte er damit einer Tradition der Burleske und des Kabaretts Tribut, die damals etwas passé schien. Madonnas Auftritte in ihrem aufreizenden Korsett, dessen Design sich auch auf die kegelförmigen BHs der 1950er-Jahre bezog, wurden jedoch vom Publikum begeistert aufgenommen, da die Unterwäsche dem Oberkörper sehr weibliche Proportionen verlieh. Kurz darauf griff Vivienne Westwood in ihrer *Portrait* Collection das klassische Korsett des 18. Jahrhunderts wieder auf. Anders als im 19. Jahrhundert, als die Frauen unter dem unvermeidlichen Druck des Korsetts auf Rippen, Hüften und Lunge litten, gaben moderne Komponenten dem Korsett die nötige Flexibilität.

Es wurde nun als reguläre Oberbekleidung getragen, kombiniert mit tiefsitzenden Jeans, einem Lederrock oder Baggy Pants, und manchmal über einem weißen T-Shirt. Darüber hinaus fand das Korsett unter Fetischisten und BDSM-Anhängern, die es als Symbol der dominanten, emanzipierten Frau sahen, überzeugte Anhänger. Dadurch wandelte sich die Wahrnehmung des Korsetts, das in den 1910er-Jahren von den ersten Feministinnen aufgrund der körperlichen Einschränkungen, die es den Frauen auferlegte, abgelehnt worden war, völlig.

THE QUINTESSENTIAL PIECES OF CLOTHING FROM THE 1990s

Faux–fur coats

Once a desirable commodity and a symbol of high social status, wearing fur coats made from exotic or endangered animal species was judged to be unacceptable by the end of the 1970s. The cruelty experienced by animals preyed on for their fur shocked the public and opinions around the globe called for the practice to be stopped. The fashion industry eventually endorsed the moral ban on natural fur. In a campaign launched by PETA (People for the Ethical Treatment of Animals) in 1994, Naomi Campbell, Cindy Crawford and other top models posed nude in support of the organization's slogan "I'd rather be naked than wear fur." Around the same time, some women who wore natural fur coats in public faced their clothing being sprayed with paint by animal defence activists, a gesture that prompted the industry to switch to high-quality imitation fur, an alternative that had been available for several decades. Calvin Klein was the first brand to completely renounce the use of animal fur in 1994, and others gradually introduced synthetic fur into their collections. Wearing a faux-fur coat became a political statement. The hip-hop scene enthusiastically followed the new craze for faux fur as a way to mimic the posh by donning eye-catching coats in eccentric hues.

Kunstpelzmäntel

Das Tragen von Pelzmänteln exotischer oder vom Aussterben bedrohter Tierarten, einst eine begehrte Ware und ein Symbol für hohen sozialen Status, wurde Ende der 1970er-Jahre als inakzeptabel eingestuft. Die Grausamkeiten, die den Tieren wegen ihrer Pelze angetan wurden, schockierten die Öffentlichkeit. Weltweit wurde die Abschaffung dieser Praxis gefordert. Die Modeindustrie propagierte schließlich das moralische Verbot von Naturpelz. In einer von PETA (People for the Ethical Treatment of Animals) 1994 gestarteten Kampagne posierten Naomi Campbell, Cindy Crawford und andere Topmodels nackt, um den Slogan „Ich bin lieber nackt als Pelz zu tragen" zu unterstützen. Etwa zur gleichen Zeit begannen Tierschützer, Frauen, die in der Öffentlichkeit Naturpelzmäntel trugen, mit Farbe zu besprühen. Diese Geste veranlasste die Industrie, auf hochwertige Pelzimitate umzusteigen, eine Alternative, die bereits seit mehreren Jahrzehnten erhältlich war. Calvin Klein war die erste Marke, die 1994 vollständig auf die Verwendung von Tierpelz verzichtete, und auch andere führten nach und nach Kunstpelz in ihre Kollektionen ein. Das Tragen eines Kunstpelzmantels wurde zu einem politischen Statement. Die Hip-Hop-Szene folgte der neuen Begeisterung für Kunstpelz, um mit auffälligen Mänteln in exzentrischen Farbtönen die High Society zu imitieren.

THE QUINTESSENTIAL PIECES OF CLOTHING FROM THE 1990s

Low-rise jeans

In the early 1960s, hip-hugger jeans were the first pants with a lower waistline to hit the market. In the spirit of the time, the legs were flared or bell-bottomed. The hip-huggers' popularity was immediate and lasted well into the 1970s and the disco years, even becoming a fashion symbol of the era. In the mid-1990s, the lowest-rise jeans, called the "bumster" was introduced under the creative vision of Alexander McQueen. A more radical version of the hip-hugger, its waistline was no longer on the middle of the hips but on the bottom, thus showing off the top of the wearer's buttocks, and the cut was slim, or straight, thus following the trend of the 1980s.

The first impression was that these jeans were defying gravity and that you were in danger of showing off a bit too much. However, it was in line with the "heroin chic" style embodied by super model Kate Moss, who was among the first celebrities to endorse these low-rise jeans. By the end of the decade, they had become a staple among teenagers, and all major celebrities of the time, such as American singer Britney Spears, British actress Keira Knightley, global socialite Paris Hilton were spotted wearing low-rise jeans.

Low-Rise-Jeans

Anfang der 1960er-Jahre kamen mit der Hüftjeans die ersten Hosen mit niedrigerer Bundhöhe auf den Markt. Dem damaligen Zeitgeist entsprechend waren es Schlaghosen. Diese Jeans waren schnell populär und hielten sich bis weit in die 1970er-Jahre. Sie wurden zu einem Modesymbol der Disco-Jahre. Mitte der 1990er erschien unter der kreativen Leitung von Alexander McQueen die „Bumster" genannte Jeans mit extrem niedrigen Bund. Sie war eine radikalere Version der Hüftjeans, deren Bund nicht mehr mittig auf der Hüfte, sondern am unteren Ende lag und so den oberen Teil des Gesäßes der Trägerin zur Geltung brachte. Diese Jeans schien zwar der Schwerkraft zu trotzen, ließ im Zweifel aber etwas zu tief blicken.

Sie entsprach jedoch dem „Heroin-Chic", den das Supermodel Kate Moss verkörperte. Sie gehörte zu den ersten Prominenten, die diese Low-Rise-Jeans trugen. Gegen Ende des Jahrzehnts war sie unter Teenagern zum Standard geworden. Alle großen Stars dieser Zeit, wie Britney Spears, Keira Knightley und Paris Hilton, wurden in Low-Rise-Jeans abgelichtet.

Nylon shell suits

Even if you miss the somewhat eccentric fashion spirit of the 1990s, you might not long for the comeback of the nylon shell suit, which became an ubiquitous athleisure outfit at the very end of the 80s and gained extreme popularity over the following decade. Hip-hop fans and break-dancers were among the first people to endorse this mutation of the traditional tracksuit that offered the advantage of being lightweight, waterproof, and comfortable thanks to its inner cotton lining. The flashy colours and geometric shapes that adorned it might look, in retrospect, appallingly ugly as if they were cut out of a discarded parachute, or, as one fashion blogger noted, they "made people look like a packet of Refreshers", but back then they were a symbol of dynamism and modernity. True, you might feel sweaty after wearing your shell suit for any length of time due to the non-breathable nature of nylon – and despite the cotton lining that absorbed part of the perspiration. And it was also recommended that you keep away from fire, as an ignited shell suit would transform you into a living torch in no time. This, however, did not deter world class musicians such as Rod Stewart, Elton John, and Missy Elliott from wearing one on numerous occasions, as did many of us freely and even proudly, unaware that in the future we might be embarrassed by pictures showing us in ridiculous shell suits. Yet, if you like a bit of originality, you can obviously grab an old shell suit from your parents' attics and sport it on the street – you will not go unspotted, guaranteed.

Trainingsanzüge aus Nylon

Selbst wenn Sie den etwas exzentrischen Modegeist der 1990er-Jahre vermissen, werden Sie sich vielleicht nicht nach dem Comeback der Trainingsanzüge aus Nylon sehnen, die Ende der 80er-Jahre zum allgegenwärtigen Athleisure-Outfit wurden und im darauffolgenden Jahrzehnt extrem an Popularität gewannen. Hip-Hop-Fans und Breakdancer gehörten zu den ersten Liebhabern dieser Abwandlung des traditionellen Trainingsanzugs, der dank seines Baumwollinnenfutters leicht, wasserfest und bequem ist. Die schrillen Farben und geometrischen Formen, die für sie verwendet wurden, mögen im Nachhinein erschreckend hässlich aussehen. Sie wirkten, als ob sie aus einem ausrangierten Fallschirm stammten. Ein Modeblogger fand, dass sie „die Träger wie ein Kaugummi aussehen" ließen, aber damals waren diese Anzüge ein Symbol für Dynamik und Modernität. Zweifellos könnten Sie sich nach längerem Tragen Ihres Trainingsanzugs verschwitzt fühlen und zwar trotz des Baumwollfutters, das einen Teil des Schweißes absorbiert, da Nylon nicht atmungsaktiv ist.

Außerdem wurde empfohlen, sich von Feuer fernzuhalten, da ein Trainingsanzug, der Feuer fängt, Sie in kürzester Zeit in eine lebende Fackel verwandeln würde. Dies hielt jedoch Weltklassemusiker wie Rod Stewart, Elton John und Missy Elliott nicht davon ab, bei zahlreichen Gelegenheiten einen solchen Anzug zu tragen, ebenso wie viele von uns, die dies freimütig und sogar stolz taten, nicht ahnend, dass wir später durch Bilder, die uns in lächerlichen Trainingsanzügen zeigen, in Verlegenheit gebracht werden könnten. Wenn Sie es jedoch originell mögen, können Sie natürlich auch einen alten Trainingsanzug vom Dachboden Ihrer Eltern klauen und damit auf die Straße gehen – Sie werden garantiert auffallen.

One–strap overalls

Was it minimalism (one strap is enough), deconstruction (and its love for asymmetric shapes), grunge (who cares about straps?), or simply fun that led to the trend of fastening just one strap of the overall? Some fashion historians attribute the origin of this style to the hip-hop scene, as a loose strap would give dancers more freedom of movement, but it seems that Will Smith's character in *The Fresh Prince of Bel Air* (1990) greatly contributed to popularising the look. It was simply cool enough to appeal to the young generation, plus it offered the advantage of getting your overalls removed faster when you needed to use the restroom.

Another variant was to wear the overall with a belt, let the front flat down, and the back straps hanging in the air like tails. The trendiest overalls were baggy, and ripped, of course.

THE QUINTESSENTIAL PIECES OF CLOTHING FROM THE 1990s

One–Strap Overalls

War es Minimalismus (ein Riemen reicht), Dekonstruktion (und die Vorliebe für asymmetrische Formen), Grunge (wen interessieren schon Riemen?) oder einfach Humor, der zum Trend führte, nur einen Riemen am Overall zu befestigen? Einige Modeexperten führen den Ursprung dieses Stils auf die Hip-Hop-Szene zurück, da ein loser Träger den Tänzern mehr Bewegungsfreiheit bot. Aber es scheint, dass Will Smiths Figur in *The Fresh Prince of Bel Air* (1990) wesentlich zur Popularisierung des Looks beitrug. Er war einfach hip genug, um die junge Generation anzusprechen, und hatte den Vorteil, dass man den Overall schneller ausziehen konnte, wenn man auf die Toilette musste.

Eine andere Variante bestand darin, den Overall mit einem Gürtel zu tragen, die Vorderseite flach herunterhängen zu lassen und die hinteren Träger wie Schwänze in der Luft baumeln zu lassen. Die angesagtesten Overalls waren natürlich ausgebeult und zerrissen.

Plaid flannel shirts

Nothing spells grunge more than an oversized plaid flannel shirt paired with ripped jeans and a band tee. Add a beanie, a pair of Timberland boots, and a choker necklace, just for fun, and you are back in the 1990s! The plaid flannel shirt could be used in many ways: as a throw-on jacket, tied around the hips, paired with a pair of baggy jeans and a crop top, with a leather miniskirt and fishnet stockings, or as a part of a Western-style look. While wearing a flannel shirt was a kind of anti-fashion statement in the early 1990s, many people sported one primarily to enjoy the warm softness of flannel, and it fit in with the laidback, comfortable, and casual attire that was all the rage at the time. In addition, this might explain the lasting popularity of flannel shirts, which are now a staple of the hipster community, where they are praised for their earthy and artisanal feel.

Karierte Flanellhemden

Nichts steht mehr für Grunge als ein übergroßes, kariertes Flanellhemd, gepaart mit Ripped Jeans und einem Band-T-Shirt. Dazu eine Mütze, ein Paar Timberland-Stiefel und eine Halskette, und man ist zurück in den 1990ern! Das karierte Flanellhemd ist vielseitig einsetzbar: als Überwurfjacke, um die Hüften gebunden, kombiniert mit Baggy Jeans und einem Crop Top, mit einem Leder-Minirock und Netzstrümpfen oder als Teil eines Western-Looks.

Während das Flanellhemd in den frühen 1990er-Jahren eine Art Anti-Mode-Statement war, trugen viele Menschen es vor allem, weil es wahnsinnig weich und bequem war. Es passte zu der entspannten, bequemen und lässigen Kleidung, die zu dieser Zeit in Mode war. Das wiederum erklärt auch die anhaltende Beliebtheit von Flanellhemden als rustikaler Bestandteil der heutigen Hipster-Szene.

Platform shoes

High-heeled shoes have been worn in various cultures since Antiquity – first in China and Greece, then in Italy at the beginning of the Renaissance – for both practical and aesthetic reasons: they gave the wearer some additional height, protected the feet from the dust and puddles on the streets, and were considered a seductive accessory. Modern-day platform shoes have been regularly in and out of fashion from the early 1930s, and their revival in the 1990s owed a lot to a nostalgic wave about the 1970s, when both men and women wore them at discos. Thanks to Vivienne Westwood and Naomi Campbell, they made a spectacular comeback in 1993, when the top model fell on the catwalk while wearing 9-inch-high platform shoes. Fortunately, she easily stood back up and walked on with a smile on her face, instead of the much-feared wrenched ankle. One year later, the Spice Girls made their resounding debut on the concert stage wearing platform shoes that set the tone for the rest of the decade: theirs were eye-catching, sneaker-like, and glittering.

Plateauschuhe

High Heels wurden seit der Antike in verschiedenen Kulturen getragen – zunächst in China und Griechenland, dann in Italien zu Beginn der Renaissance – und zwar sowohl aus praktischen als auch aus ästhetischen Gründen: Sie verliehen der Trägerin zusätzliche Höhe, schützten die Füße vor Staub und Pfützen auf den Straßen und galten als verführerisches Accessoire. Die heutigen Plateauschuhe sind seit den frühen 1930er-Jahren immer wieder aus der Mode gekommen, und ihr Wiederaufleben in den 1990er-Jahren ist vor allem einer nostalgischen 70er-Welle zu verdanken, als sie sowohl von Männern als auch von Frauen in Diskotheken getragen wurden. Dank Vivienne Westwood und Naomi Campbell erlebten sie 1993 ein spektakuläres Comeback, als das Topmodel auf dem Laufsteg stürzte, während sie neun Zentimeter hohe Plateauschuhe trug. Glücklicherweise stand sie problemlos wieder auf und lief mit einem Lächeln im Gesicht weiter, statt des gefürchteten verstauchten Knöchels. Ein Jahr später gaben die Spice Girls ihr durchschlagendes Debüt auf der Konzertbühne und trugen Plateauschuhe, die den Ton für den Rest des Jahrzehnts angaben: Sie waren auffällig, sneakerartig und glitzernd.

Ripped jeans

Many a classic-style fashionista in the 1990s was shocked to see a pair of ripped jeans in the front window of a fashion store. The very idea of buying a pair of torn jeans still seemed incongruous to many, as did the idea of wearing them. A very strong symbol of counterculture and rebellion, ripped jeans perfectly illustrated the principle of grunge fashion: you were too cool to worry about distressed clothes. They were the ideal companion to an oversized flannel shirt and Timberland shoes, or to a punk look.

By the end of the decade, however, the acceptance of jeans with ripped knees as elements of fashion was widespread enough to see them worn with white shirts and blazers, thus joining the more stylish panoply. It is now admitted that ripped jeans – especially black jeans – add a touch of edginess to your outfit. They take it from boringly conformist to quirky and original. Additionally, you may opt not to buy ripped jeans, but to hold onto your old, worn-out pair and adorn it with holes and frays, giving it a second life.

Ripped Jeans

In den 1990er-Jahren waren so manche Modemenschen schockiert, als sie zerrissene Jeans im Schaufenster eines Modegeschäfts sahen. Allein die Vorstellung, eine zerrissene Jeans zu kaufen, erschien vielen noch unpassend, ebenso wie die Idee, sie zu tragen. Als starkes Symbol der Rebellion veranschaulichte die Ripped Jeans perfekt das Prinzip der Grunge-Mode: Man war zu hip, um sich Gedanken über zerrissene Kleidung zu machen. Sie waren die ideale Ergänzung zu einem übergroßen Flanellhemd, zu Timberland-Schuhen oder zu einem Punk-Look.

Gegen Ende des Jahrzehnts war die Akzeptanz von Jeans mit zerrissenen Knien als modisches Element jedoch so weit verbreitet, dass sie mit weißen Hemden und Blazern getragen wurden und sich so in die stilvollere Garderobe einreihten. Heute ist es unbestritten, dass Ripped Jeans – insbesondere schwarze – dem Outfit einen Hauch von Coolness verleihen. Sie machen aus einem langweiligen Outfit ein ausgefallenes und originelles. Man kann sich auch dafür entscheiden, keine zerrissene Jeans zu kaufen, sondern seine alte, abgenutzte Jeans zu behalten und sie mit Löchern und Fransen zu verschönern, um ihr ein zweites Leben zu geben.

Slip dresses

Take any female celebrity of the 1990s and you will inevitably find a picture of her in a slip dress, for they were the quintessential fashion piece of the decade. No look is more emblematic of the 1990s than this minimal garment with its easy, fluid lines. The appeal has never ended since Kate Moss, Naomi Campbell, Courtney Love, Lady Diana, Halle Berry, and Gwyneth Paltrow made it the ultimate fashion staple for any occasion, day or night.

Simple and versatile, it provides the wearer with a modern and elegant allure and can easily be paired with more sophisticated accessories or with a basic t-shirt and combat boots. You can look punk, casual, or super elegant in the same slip dress depending on how you style it, and you are ready for a formal evening, a dance club, a date, or a brunch with friends. While the original models were made of silk – as was the piece of lingerie from the 1920s that inspired the slip dress of the 1990s – you have now a wide range of fabrics available such as satin, cotton, sheer, stretch, or velvet.

Page 188: Cameron Diaz posing in a red slip dress for *There's Something about Mary*, 1998

Seite 188: Cameron Diaz posiert in einem roten Slip-Kleid für *Verrückt nach Mary*, 1998

Page 189: Actress Sarah Jessica Parker, New York, 1997

Seite 189: Die Schauspielerin Sarah Jessica Parker, New York, 1997

THE QUINTESSENTIAL PIECES OF CLOTHING FROM THE 1990s

Slip Dresses

Jede weibliche Berühmtheit der 1990er-Jahre wird man unweigerlich in einem Slip Dress abgebildet finden, denn es war der Inbegriff der Mode dieses Jahrzehnts. Kein Look ist so typisch für die 1990er-Jahre wie dieses minimalistische Kleidungsstück mit seinen leichten, fließenden Linien. Seit Kate Moss, Naomi Campbell, Courtney Love, Lady Diana, Halle Berry und Gwyneth Paltrow es zum ultimativen Kleidungsstück für jeden Anlass, ob Tag oder Nacht, machten, hat die Anziehungskraft nie nachgelassen.

Schlicht und vielseitig, verleiht es seiner Trägerin eine moderne und elegante Ausstrahlung und kann problemlos mit raffinierten Accessoires oder mit einem einfachen T-Shirt und Springerstiefeln kombiniert werden. Je nachdem, wie man sich stylt, kann man in ein und demselben Slip Dress punkig, lässig oder elegant aussehen. Man ist bereit für einen formellen Abend, einen Tanzclub, ein Date oder einen Brunch mit Freunden. Während die ursprünglichen Modelle aus Seide bestanden – wie auch Dessous aus den 1920er-Jahren, die das Slip Dress der 1990er-Jahre inspirierten –, gibt es heute eine große Auswahl an Stoffen wie Satin, Baumwolle, durchsichtige Materialien, Stretch oder Samt.

Spaghetti-strap tank tops

A symbol of 1990s' minimalist fashion, spaghetti-strap tank tops have enjoyed a lasting revival in the 2020s, switching again from the yoga classes and activewear to the catwalk. Simple and form fitting, it retains all the freedom of movement while looking more chic and less loose than the classic tank top. It can be easily paired with trousers, a skirt, a tracksuit, or layered on top of a t-shirt or underneath a blouse. In essence and shape, the spaghetti-strap tank top was quite similar to the slip dress: both followed the "underwear-as-outerwear" trend that emerged in the 1990s. They constituted, along with the crop top, the heart of the risky, sexy, and feminine side of the decade's fashions, thus counterbalancing the strong unisex-oversized trend symbolised by hip-hop elements such as baggy pants and xxl t-shirts.

Spaghettiträger – Tank – Tops

Als Symbol für die minimalistische Mode der 1990er-Jahre haben Spaghettiträger-Tank-Tops in den 2020er-Jahren ein nachhaltiges Revival erlebt und sind von Yogakursen und Sportbekleidung auf den Laufsteg zurückgekehrt. Das schlichte, körperbetonte Modell bietet viel Bewegungsfreiheit und sieht gleichzeitig schicker aus als ein klassisches Tank-Top. Es lässt sich leicht mit einer Hose, einem Rock oder einem Trainingsanzug kombinieren sowie über einem T-Shirt oder unter einer Bluse tragen.
Das Spaghettiträger-Top ist in seinem Wesen und seiner Form dem Slip Dress sehr ähnlich: Beide folgten dem in den 1990er-Jahren aufkommenden Trend, Unterwäsche als Oberbekleidung zu tragen. Zusammen mit dem Crop Top bildeten sie das Herzstück der riskanten, sexy und femininen Seite der Mode dieses Jahrzehnts und waren so ein Gegengewicht zu dem starken Unisex-Trend in Übergröße, symbolisiert durch Hip-Hop-Elemente wie Baggy Pants und XXL-T-Shirts.

Swirl-print flared pants

The 1990s had their own psychedelic moment, which was greatly inspired by the 1960s, although this decade's swirl-print flared pants were mostly two-coloured, far from the flamboyance of the hippie fashion. The aim was not necessarily to capture the delirious visions experienced under psychotropic drugs, but to create a mesmerising movement effect that would compellingly attract the eye. Some of these swirl patterns are reminiscent of graphic works by pop-art artist Keith Haring (1958–1990), whose pop-art, labyrinth-like drawings, characterised by simple lines and a minimalist iconography, marked the decade, and contributed to the popularity of street art and graffiti. While they were mainly associated with flared pants, you could find swirl patterns on skirts, leggings, dresses, and even accessories such as earrings, as an alternative to the ubiquitous hoops.

Schlaghose mit Swirl-Print

Die 1990er-Jahre hatten ihre eigene psychedelischen Komponente, die stark von den 1960ern inspiriert war, auch wenn die Schlaghosen mit Swirl-Print in diesem Jahrzehnt meist zweifarbig waren, weit entfernt von der Extravaganz der Hippie-Mode. Es ging nicht unbedingt darum, die unter Psychopharmaka erlebten deliranten Visionen einzufangen, sondern darum, einen hypnotisierenden Bewegungseffekt zu erzeugen, der das Auge fesselt. Einige dieser Wirbelmuster erinnern an die grafischen Arbeiten des Pop-Art-Künstlers Keith Haring (1958–1990), dessen labyrinthartige Pop-Art-Zeichnungen, die sich durch einfache Linien und eine minimalistische Ikonografie auszeichnen, das Jahrzehnt prägten und zur Popularität von Street Art und Graffiti beitrugen. Während sie vor allem mit Schlaghosen in Verbindung gebracht wurden, konnte man Swirl-Muster auch auf Röcken, Leggings, Kleidern und sogar auf Accessoires wie Ohrringen finden, als Alternative zu den allgegenwärtigen Kreismustern.

Timberland shoes

If you were buying a pair of Timberland Waterproof Shoes in the late 1970s, you were likely from the blue-collar class – the shoes were designed as working boots for workers in factories and people in the fields who had to face humid and cold weather. No matter whether you were a farmer, a lumberjack, or a forest ranger, you would enjoy the waterproof comfort of the beige nubuck shoes. In the early 1980s, Italian Piaggio drivers discovered the qualities of the Timbs, which were the perfect shoes for driving a motor scooter in adverse weather.

At the end of the same decade, sales started to rocket in NYC, as drug dealers adopted the Timberland waterproof boots for their long night shifts on the streets. The fact that they were now associated with thugs was reason enough for rap singers to wear shoes as part of the gangsta look, they were fond of, and Timberland-mania spread across the world to the rhythms of rap.

Timberland– Schuhe

Wenn man in den späten 1970er-Jahren ein Paar wasserdichte Timberland-Schuhe kaufte, gehörte man wahrscheinlich zur Arbeiterklasse. Die Schuhe waren für Arbeiter in Fabriken und auf dem Feld konzipiert, die mit feuchtem und kaltem Wetter zu kämpfen hatten. Ganz gleich, ob Landwirt, Holzfäller oder Förster, man profitierte vom wasserdichten Komfort der beigen Schuhe aus Nubukleder. In den frühen 1980er-Jahren entdeckten italienische Piaggio-Fahrer die Qualitäten der Timbs, die sich perfekt zum Fahren eines Motorrollers bei schlechtem Wetter eigneten.

Ende desselben Jahrzehnts begannen die Verkaufszahlen in New York City in die Höhe zu schnellen, als Drogendealer die wasserdichten Timberland-Stiefel für ihre langen Nachtschichten auf der Straße übernahmen. Die Tatsache, dass sie nun mit Gangstern assoziiert wurden, war für Rapper Grund genug, die Schuhe als Teil ihres Gangsta-Looks aufzunehmen. Die Timberland-Manie verbreitete sich im Takt des Rap über die ganze Welt.

THE QUINTESSENTIAL PIECES OF CLOTHING FROM THE 1990s

201

Velour tracksuits

Comfort and function in one: the hedonistic velour tracksuit perfectly reflects the fashion aspirations of the 1990s and the quest for easy cosiness. One can only wonder why velour tracksuits took until the last years of the decade to become a staple of casual daywear. Ever since, they have been the perfect outfit for a cocooning session, a comfortable flight, a shopping afternoon or a visit to the dentist, and the predominantly pastel shades enhance this sense of relaxation. Interestingly, velour tracksuits were never primarily meant for sporting activities, as velour is a relatively delicate, soft material. The trend took off thanks to the high-end styles launched by Juicy Couture at the end of the decade, when Paris Hilton, Britney Spears, Jennifer Lopez, and other celebrities were photographed by paparazzi in elegant velour tracksuits paired with luxury accessories. These tracksuits were a far cry from the utilitarian, velour uniforms of the *Star Trek* characters, which were the first ones to popularise the fabric in the late 1960s.

Velours–Trainingsanzüge

Komfort und Funktion in einem: Der hedonistische Velours-Trainingsanzug spiegelt perfekt den modischen Anspruch der 1990er-Jahre und das Streben nach unkomplizierter Bequemlichkeit wider. Man kann sich nur wundern, warum Velours-Trainingsanzüge erst in den letzten Jahren des Jahrzehnts zu einem festen Bestandteil der Tageskleidung wurden. Seitdem sind sie das perfekte Outfit für eine Cocooning-Session, einen gemütlichen Flug, einen Shopping-Nachmittag oder einen Zahnarztbesuch. Die überwiegend pastellfarbenen Töne verstärken dieses Gefühl der Entspannung. Interessanterweise waren Velours-Trainingsanzüge nie primär für sportliche Aktivitäten gedacht, denn Velours ist ein relativ zartes, weiches Material. Der Trend wurde durch die von Juicy Couture Ende des Jahrzehnts auf den Markt gebrachten High-End-Modelle ausgelöst, als Paris Hilton, Britney Spears, Jennifer Lopez und andere Prominente von Paparazzi in eleganten Velours-Trainingsanzügen mit Luxus-Accessoires fotografiert wurden. Diese Trainingsanzüge waren weit entfernt von den utilitaristischen Velours-Uniformen der *Star-Trek*-Figuren, die den Stoff Ende der 1960er-Jahre als erste populär gemacht hatten.

THE QUINTESSENTIAL PIECES OF CLOTHING FROM THE 1990s

203

Velvet suits

There was a hint of the 1920s and 1970s in the revival of velvet in the mid-1990s. However, while velvet was associated in the previous decades with partying, excesses, and stylish decadence, velvet suits were seen now as the epitome of minimalist chic and glamourous comfort. This new trend was best exemplified by Gwyneth Paltrow's red velvet suit at the MTV Video Music Awards in 1996. The then 24-year-old actress was at the height of her Hollywood career, and the suit designed by Tom Ford for Gucci got as viral as it was possible in those early days of the Internet. Ford's inspiration clearly derived from the disco era, and while the suit could have been worn at the iconic *Studio 54*, its straight lines and minimalist design were definitely in the spirit of the 1990s.

Page 203: Jessica Alba in her light blue velour tracksuit

Samt– anzüge

Die Wiederbelebung von Samt Mitte der 1990er-Jahre erinnert an die 1920er- und 1970er-Jahre. Doch während Samt in den vorangegangenen Jahrzehnten mit Partys, Exzessen und stilvoller Dekadenz assoziiert wurde, galten Samtanzüge nun als Inbegriff von minimalistischem Chic und glamourösem Komfort. Das beste Beispiel für diesen neuen Trend war der rote Samtanzug von Gwyneth Paltrow bei den MTV Video Music Awards 1996. Die damals 24-jährige Schauspielerin befand sich auf dem Höhepunkt ihrer Hollywood-Karriere und der von Tom Ford für Gucci entworfene Anzug verbreitete sich so schnell, wie es in jenen frühen Tagen des Internets möglich war. Fords Inspiration stammte eindeutig aus der Disco-Ära und obwohl der Anzug auch im kultigen *Studio 54* hätte getragen werden können, entsprachen seine geraden Linien und sein minimalistisches Design definitiv dem Geist der 1990er-Jahre.

Seite 203: Jessica Alba in ihrem hellblauen Velours-Trainingsanzug

Vinyl pants

When vinyl clothes came back into fashion in the early 1990s, it looked as if the 1960s were suddenly resurfacing, and the futuristic vinyl clothes designed by Paco Rabanne, André Courrèges and Pierre Cardin were once again transforming models into space travellers. However, the new vinyl designs of the 1990s, particularly the pants, were mostly intended for disco parties where their tight and shiny aspect added a touch of style to the wearers. Whether in black – the predominant colour – or in flashier hues, such as red, purple, or yellow you were sure to capture attention in such an eye-catching garment. True, you would look halfway between a Marvel super-hero and a fan of BDSM, but nothing was really surprising in the 1990s! By the mid-decade, Versace launched their winter-fall 1995 collection with vinyl clothes worn by top models Claudia Schiffer and Cindy Crawford, thus opening a new chapter in the history of this synthetic rubber compound, which was accidentally discovered in 1926 by Waldo Semon, an American chemist.

Britney Spears performing in a vinyl outfit, Rosemont, Illinois, 1999

Vinyl-Hosen

Als Anfang der 1990er-Jahre die Vinylkleidung wieder in Mode kam, schien es, als würden die 60er plötzlich wieder aufleben. Die futuristischen Vinylkleider von Paco Rabanne, André Courrèges und Pierre Cardin verwandelten die Models erneut in Raumfahrer. Die neuen Vinyl-Designs der 1990er-Jahre, vor allem die Hosen, waren jedoch vor allem für Disco-Partys gedacht, wo ihr enges und glänzendes Aussehen den Trägerinnen einen Hauch von Stil verlieh. Ob in Schwarz – der vorherrschenden Farbe – oder in schrilleren Tönen wie Rot, Lila oder Gelb: In einem solch auffälligen Kleidungsstück konnte man sich der Aufmerksamkeit sicher sein. Zugegeben, man sah aus wie ein Marvel-Superheld oder BDSM-Fan, aber in den 1990er-Jahren war nichts wirklich überraschend! Mitte des Jahrzehnts brachte Versace seine Winter-Herbst-Kollektion 1995 mit Kleidern aus Vinyl auf den Markt, die von den Topmodels Claudia Schiffer und Cindy Crawford getragen wurden. Damit wurde ein neues Kapitel in der Geschichte dieser synthetischen Kautschukverbindung aufgeschlagen, die 1926 zufällig vom amerikanischen Chemiker Waldo Semon entdeckt worden war.

Britney Spears bei einem Auftritt in einem Vinyl-Outfit, Rosemont, Illinois, 1999

Accessories

It would be quite challenging to feature all the fashion accessories that were in style in the 1990s: therefore, only the most iconic ones have been selected. Not so surprisingly, most of them have made a recent comeback into fashion.

Accessoires

Es wäre eine ziemliche Herausforderung, alle Modeaccessoires vorzustellen, die in den 1990er-Jahren in Mode waren. Daher wird hier nur auf die kultigsten eingegangen. Es überrascht nicht, dass die meisten von ihnen in letzter Zeit ein modisches Comeback erlebt haben.

Bandanas

The paisley bandana switched from the hippie panoply of the 1970s to hip-hop fashion in the 1990s through the subculture of street gangs where it acted as a signifier for being a member. A versatile accessory, it was worn in the 1990s as a headband, a scarf, or a top – as an alternative to the tube top.

Bandanas

Das Paisley-Bandana wechselte vom Hippielook der 1970er-Jahre zum Hip-Hop Style der 1990er-Jahre durch die Subkultur der Straßenbanden, bei denen es als Zeichen der Zugehörigkeit diente. Dieses vielseitige Accessoire wurde in den 1990er-Jahren als Stirnband, Schal und Oberteil (als Alternative zum Röhrentop) getragen.

Butterfly clips

From Gwen Stefani to Jennifer Aniston and Britney Spears, all rising stars of the 1990s adopted the small, versatile, and poetic butterfly clips that gave your hairdo some personality and secured sections of hair to keep them out of your eyes.

Haarklammern

Von Gwen Stefani über Jennifer Aniston bis hin zu Britney Spears – alle aufstrebenden Stars der 1990er-Jahre griffen zu den kleinen, vielseitigen und poetischen Haarklammern, die ihrer Frisur Persönlichkeit verliehen und Haarpartien fixierten, die ihnen sonst in die Augen gefallen wären.

Bucket hats

A cotton variant of the tweed Irish walking hat, the bucket hat was adopted by the hip-hop community in the late 1980s for its practicality: it stays firmly on your head, protects you from rain and sun, and can be easily folded and stored in a small pocket.

Fischerhüte

Der Fischerhut ist eine Baumwollvariante des irischen Wanderhuts aus Tweed und wurde in den späten 1980er-Jahren von der Hip-Hop-Gemeinde aufgrund seiner praktischen Eigenschaften übernommen: Er bleibt fest auf dem Kopf sitzen, schützt vor Regen und Sonne und lässt sich leicht zusammenfalten und in einer kleinen Tasche verstauen.

Choker necklaces

In past centuries, choker necklaces were primarily popular among the aristocracy and femmes fatales. They became a widespread accessory in the early 1990s, adding a touch of elegance and edgy flair to any style. Fans of punk and grunge used spiked dog collars instead.

Choker

In den vergangenen Jahrhunderten waren Choker vor allem bei der Aristokratie und den Femmes fatales beliebt. In den frühen 1990er-Jahren wurden sie zu einem weit verbreiteten Accessoire, das jedem Stil einen Hauch von Eleganz und Unangepasstheit verleiht. Fans von Punk und Grunge verwendeten stattdessen Stachelhalsbänder.

Coloured sunglasses

After decades of extra-large sunglasses, the 1990s saw a shift towards small, thin-framed sunglasses with tinted glasses ranging from pink to green and from yellow to purple that perhaps led to wearers seeing the world in a different colour. In spite of the eccentric tints, these oval sunglasses marked a comeback to basic shapes and the (temporary) end of super-sized sunglasses that covered half of the face.

Farbige Sonnenbrillen

Nach Jahrzehnten übergroßer Sonnenbrillen verschob sich der Trend in den 1990er-Jahren hin zu kleinen Sonnenbrillen mit schmalen Rahmen und getönten Gläsern, die von Rosa bis Grün und von Gelb bis Lila reichten und mitunter dazu beitrugen, dass die Träger die Welt in einer anderen Farbe sahen. Trotz der exzentrischen Tönungen markierten diese ovalen Sonnenbrillen eine Rückkehr zu den Grundformen und das (vorläufige) Ende der übergroßen Sonnenbrillen, die das halbe Gesicht verdeckten.

Fanny Packs

Once a sportswear accessory for skiers, joggers and tourists, fanny packs were not really considered chic or cool until Karl Lagerfeld launched a series of luxury fanny packs for Chanel in 1994, thus elevating them up to the most select catwalks. Around the same time, more affordable versions evolved from the not so figure-flattering "bumbag" to more elegant cross-torso variants.

Bauchtaschen

Bauchtaschen, die einst ein Accessoire für Skifahrer, Jogger und Touristen waren, galten nicht wirklich als schick oder cool, bis Karl Lagerfeld 1994 für Chanel eine Serie luxuriöser Bauchtaschen auf den Markt brachte und sie damit auf die exquisitesten Laufstege hievte. Etwa zur gleichen Zeit entwickelten sich die erschwinglicheren Modelle von den wenig figurschmeichelnden Bauchtaschen hin zu eleganteren Varianten, die über den Oberkörper getragen wurden.

Fishnet stockings

No grunge (or punk) look would be complete without a pair of fishnet stockings, best ripped, and paired with combat boots.

Netzstrumpfhosen

Kein Grunge- (oder Punk-)Look wäre komplett ohne ein Paar Netzstrümpfe und zwar am besten zerrissen und gepaart mit Boots.

Friendship bracelets

Hand-made, silk ribbon bracelets were all the rage in high schools in the early 1990s. They became a strong currency of interaction with best friends and sentimental relationships. They had to be worn day and night, as removing the bracelet from your wrist would mean the end of the friendship.

Freundschaftsarmbänder

Handgefertigte Seidenarmbänder waren Anfang der 1990er-Jahre in den Highschools der letzte Schrei. Sie wurden zu einer harten Währung für Interaktionen mit besten Freunden und Verehrern. Die Armbänder mussten Tag und Nacht getragen werden, da das Entfernen vom Handgelenk das Ende der Freundschaft bedeutet hätte.

Hair claws

As Christian Potut, the French entrepreneur who invented the hair claw, explained in an interview: "One day I kept crossing and uncrossing my fingers, and that's when I had my lightbulb moment. I said to myself: 'I sell combs and clips, why don't I combine the two?'". The now ubiquitous hair claw was launched in 1989 in Oyonnax, in the French Alps, just in time to become a beloved everyday object of the 1990s. Its main advantage is that it adapts to all hair types, from straight to curly, and from short to long.

Haarspangen

Christian Potut, ein französischer Unternehmer, der die Haarspange erfunden hat, erklärte in einem Interview: „Eines Tages schob ich meine Hände immer wieder ineinander und da ging mir ein Licht auf. Ich sagte zu mir selbst: ‚Ich verkaufe Kämme und Klammern, warum kombiniere ich nicht beides?'" Die Markteinführung der heute allgegenwärtigen Haarspangen fand 1989 in Oyonnax in den französischen Alpen statt und somit gerade rechtzeitig, damit die Spangen zu einem beliebten Alltagsgegenstand der 1990er-Jahre werden konnten. Ihr Hauptvorteil besteht darin, dass sie sich an alle Haartypen anpassen – von glatt bis lockig und von kurz bis lang.

Hoop earrings

Hoop earrings are among the oldest fashion accessories around, in fact archaeologists unearthed some models dating back to 2500 BCE in Nubia, from whence they spread through Africa, Europe, and the Middle East during Antiquity. The hoop earrings of the 1990s were particularly thin and large in diameter. These earrings became a symbol of the Latina community in the US.

Scrunchies

Inspired by the waistband of her pyjamas, singer and pianist Rommy Revson, who was allergic to metal hair clips, designed the first circular elastic tie covered with fabric in 1986, and this simple, versatile accessory became the queen of hair ornaments in the 1990s.

Creolen

Creolen gehören zu den ältesten Modeaccessoires überhaupt. Archäologen haben einige Modelle, die auf 2500 v. Chr. datiert werden, in Nubien ausgegraben, von wo aus sie in der Antike nach Afrika, Europa und den Nahen Osten kamen. Die Creolen der 1990er-Jahre waren besonders dünn und hatten einen großen Durchmesser. Diese Ohrringe wurden zu einem Symbol der Latina-Gemeinschaft in den USA.

Haargummis aus Stoff

Inspiriert vom Bund ihres Schlafanzugs entwarf die Sängerin und Pianistin Rommy Revson, die allergisch auf Metallhaarklammern reagierte, 1986 das erste runde, mit Stoff überzogene Haarband. Dieses einfache und vielseitige Accessoire wurde in den 1990er-Jahren zu dem Haarschmuck schlechthin.

Photo Credits

Front Cover: *Unpublished*, Kate Moss by Corinne Day, 1992. © Estate of Corinne Day. All rights reserved/Bridgeman Images; p. 2: © Greenseas/iStock; pp. 6-7: © Stephane Cardinale/Corbis/Getty Images; p. 10: © Carolco Pictures/TriStar Pictures/MSDB; p. 13: © mauritius images/Entertainment Pictures/Alamy/Alamy Stock Photos; pp. 14-15: © Daniel Simon/Gamma-Rapho via Getty Images; pp. 16-17: © Lindsay Brice/Getty Images; p. 18: © Thomas Iannaccone/WWD via Getty Images; p. 21: © Thomas Iannaccone/George Chinsee/Robert Mitra/WWD/Penske Media via Getty Images; p. 22: © Warner Bros./MSDB; p. 23: © Jetrel/iStock; p. 25: © Jeff Kravitz/FilmMagic, Inc/Getty Images; p. 26: © Chris Walter/WireImage/Getty Images; p. 28: © Thomas Iannaccone/WWD/Penske Media via Getty Images; p. 29: © Fairchild Archive/WWD/Penske Media via Getty Images; p. 30: © Robert Mitra/Penske Media via Getty Images; p. 33: © Anwar Hussein/WireImage/Getty Images; p. 34: © AK Photography Media/Unsplash; p. 35: © Blue Bird/Unsplash; p. 37: © Giovanni Giannoni/Penske Media via Getty Images; p. 38: © Fairchild Archive/Penske Media via Getty Images; p. 40: © Art Streiber/Penske Media via Getty Images; p. 43: © Art Streiber/Penske Media via Getty Images; pp. 44-45: © Robert Mitra/Penske Media via Getty Images; pp. 46-47: © Fairchild Archive/WWD/Penske Media via Getty Images; p. 48: © Fairchild Archive/Penske Media via Getty Images; p. 51: © Daniel Simon/Gamma-Rapho via Getty Images; p. 52: © Giovanni Giannoni/Penske Media via Getty Images; pp. 54-57: © Fairchild Archive/Penske Media via Getty Images; p. 59: © Tim Graham Photo Library via Getty Images; p. 60: © filadendron/iStock; pp. 62-63: © mauritius images / Cinema Legacy Collection; p. 65: © Image Source/iStock; p. 67: © NBC/MSDB; p. 69: © Paramount Pictures/MSDB; p. 70: © rafael barros/Pexels; p. 71: © Irina Belova/iStock; p. 72: © MarsBars/iStock; p. 73: © marcelinopozo/iStock; p. 74: © mauritius images/Allstar Picture Library Ltd/Alamy/Alamy Stock Photos; p. 75: © COP/UGC/MSDB; p. 76: © Mitchell Gerber/Corbis/VCG via Getty Images; p. 77: © Yana Tikhonova/iStock; pp. 78-79: © Arnal/Garcia/Gamma-Rapho via Getty Images; p. 81: © Pierre Vauthey/Sygma/Sygma via Getty Images; p. 82: © Fairchild Archive/Penske Media via Getty Images; pp. 85-68: © Pinewood Studios/Gaumont/MSDB; p. 87: © Vittoriano Rastelli/Corbis via Getty Images; p. 88: © Fairchild Archive/Penske Media via Getty Images; p. 90: © Pierre Vauthey/Sygma/Sygma via Getty Images; p. 91: © Victor Virgile/Gamma-Rapho via Getty Images; pp. 92-93: © Daniel Simon/Gamma-Rapho via Getty Images; p. 94: © Giovanni Giannoni/Penske Media via Getty Images; p. 95 top: © Pierre Vauthey/Sygma/Sygma via Getty Images; p. 95 bottom: © mauritius images/Anwar Hussein/Alamy/Alamy Stock Photos; p. 97: © PL Gould/Images/Getty Images; p. 99: © Dave Benett/Getty Images; pp. 100-101: © George Rose/Getty Images; pp. 102-103: © Rose Hartman/WireImage/Getty Images; p. 104 © Estate of Corinne Day. All rights reserved, 2023/Bridgeman Images; p. 106: © Thomas Coex/AFP via Getty Images; pp. 106-107: © Foc Kan/Wireimage/Getty Images; p. 109: © mauritius images/Gary Doak/Alamy/Alamy Stock Photos; pp. 110-111: © Steve Eichner/WWD/Penske Media via Getty Images; pp. 112-113 © NBC/MSDB; p. 114: © Fox/MSDB; pp. 116-117: © Paramount Pictures/MSDB; p. 118: © Jersey Films/A Band Apart/Miramax/MSDB; p. 119: © Warner Bros/Village Roadshow Pictures/Silver Pictures/MSDB; p. 121: © Ke.Mazur/WireImage/Getty Images; p. 122: © Jeff Kravitz/FilmMagic, Inc/Getty Images; p. 123: © Jeff Kravitz/FilmMagic, Inc/Getty Images; p. 124: © Ke.Mazur/WireImage/Getty Images; p. 127: © mauritius images/Anwar Hussein/Alamy/Alamy Stock Photos; p. 128: © mauritius images/Anwar Hussein/Alamy/Alamy Stock Photos; p. 129: © Anwar Hussein/Getty Images; p. 130: © mauritius images/Anwar Hussein/Alamy/Alamy Stock Photos; p. 133: © mauritius images/Anwar Hussein/Alamy/Alamy Stock Photos; p. 134: © mauritius images/Anwar Hussein/Alamy/Alamy Stock Photos; p. 136: © mauritius images/David Parker/Alamy/Alamy Stock Photos; p. 137: © Antony Jones/UK Press via Getty Images; pp. 138-139: © luoman/iStock; p. 141: © Ainnek_Ha/Pexels; pp. 142-143: © Stephane Cardinale/Sygma via Getty Images; p. 144: © Media Punch, Inc/Alamy Images; p. 147: © Khalid Boutchich/Unsplash; p. 148: © Sheldon/Unsplash; p. 149: © Polinach/Pexels; p. 151: © Lucretius Mooka/Pexels; p. 152: © Paramount Pictures/MSDB; p. 154: © FatCamera/iStock; p. 155: © Marco_Piunti/iStock; p. 157: © Godisable Jacob/Pexels; p. 158: © Nathan van de Graaf/Unsplash; p. 160: © private collection; p. 163: © Thierry Orban/Sygma via Getty Images; p. 165: © Riccardo Caliban/iStock; p. 166: © Su Arsanoglu/iStock; p. 169: © Thurteil/iStock; p. p. 171: © webphotographer/iStock; p: 172: © Tamara Bellis/Unsplash; p. 174 left: © private collection: p. 174 right: © Andrei Castanha/Unsplash; p. 175: © Corbis Documentary/Getty Images; p. 177: © m-imagephotography/iStock; p. 178: © Wirestock/iStock; p. 180: © urbazon/iStock; p. 183: © Wallace Felipe/Pexels; p. 184: © Megan Ruth/Pexels; p. 186: © Godisable Jacob/Pexels; p. 187: © RDNE Stock Project/Pexels; p. 188: © 20th Century Fox/MSDB; p. 189: © Mitchell Gerber/Corbis/VCG via Getty Images; p. 191: © Vladimir Fedotov/Unsplash; p. 192 © Darina Belonogova/Pexels; p. 195: © RedWolf/Pexels; p. 196: © Polina Tankilevitch/Pexels; p. 199: © Tom Sodoge/Unsplash; p. 200: © Caziopeia/iStock; p. 201: © Stephan Seeber/Pexels; p. 203: © L. Cohen/WireImage/Getty Images; p. 204: © Ron Galella, Ltd./Ron Galella Collection via Getty Images; p. 206: © Paul Natkin/Getty Images; p. 209: © helenaak/iStock; p. 210: © mauritius images/Jim Corwin/Alamy/Alamy Stock Photos; p. 211: © Ann Bugaichuk/Pexels; p. 212: © Shironosov/iStock; p. 213: © mediagfx/iStock; p. 214: © mikoto.raw Photographer/Pexels; p. 215: © cottonbro studio/Pexels; p. 216: © Nasim Neshmiri/Unsplash; p. 217: © 12photostory/Unsplash; p. 218: © Justin Essah/Unsplash; p. 219: © Yellow Cactus/Unsplash; pp. 220-221: © Fairchild Archive/Penske Media via Getty Images

Acknowledgements

I would like to thank the entire team at teNeues, and in particular Nadine Weinhold and Roman Korn for their constant, friendly support and valuable knowledge. I am also indebted to my long-time friend and copyeditor, Lee Ripley for spotting some inaccuracies and for her tireless enthusiasm. Many thanks to our German translators, Rebecca Rosenthal and Raimund Mayer, and to all my friends who kindly shared their funny memories of fashion in the 1990s.

A big thank you to my wife, Agata, for designing this gorgeous book, and to my daughters Emilie and Mathilde for their patience and young, passionate interest in all things fashion.

Danksagung

Ich möchte mich herzlich bei dem gesamten Team vom teNeues Verlag bedanken, insbesondere bei Nadine Weinhold und Roman Korn für ihre ständige, freundliche Unterstützung und ihr wertvolles Wissen. Ich bin auch meiner langjährigen guten Freundin und Lektorin Lee Ripley für das Aufspüren einiger Ungenauigkeiten und für ihren unermüdlichen Enthusiasmus zu Dank verpflichtet. Vielen Dank an unsere deutschen Übersetzer, Rebecca Rosenthal und Raimund Mayer, und an alle meine Bekannten, die mir freundlicherweise ihre schönen Erinnerungen an die Mode der 1990er-Jahre mitgeteilt haben.

Ein großes Dankeschön an meine Frau Agata für die Gestaltung dieses wunderschönen Buches und an meine Töchter Emilie und Mathilde für ihre Geduld und ihr junges, leidenschaftliches Interesse an allen Facetten der Mode.

Pages 220-221: Backstage picture, Calvin Klein fashion show, New York, September, 1998

Seiten 220-221: Backstage-Foto, Calvin Klein Modenschau, New York, September 1998

Front cover: Kate Moss photographed by Corinne Day, 1992

Coverbild: Kate Moss, fotografiert von Corinne Day, 1992

© 2023 teNeues Verlag GmbH

Texts: © Pierre Toromanoff, Fancy Books Packaging

Editorial Coordination by Nadine Weinhold, Roman Korn, teNeues Verlag
Production by Alwine Krebber, teNeues Verlag
Photo Editing, Color Separation by Jens Grundei, teNeues Verlag
Layout and cover design by Agata Toromanoff, Fancy Books Packaging

Translation into German by Rebecca Rosenthal, Raimund Mayer
Copyediting by Lee V. Ripley (English), Nadine Weinhold (German)

ISBN: 978-3-96171-520-6
Library of Congress Number: 2023942681

Printed in Slovakia by Neografia a.s.

FSC MIX Paper | Supporting responsible forestry FSC® C020353

Picture and text rights reserved for all countries. No part of this publication may be reproduced in any manner whatsoever.

While we strive for utmost precision in every detail, we cannot be held responsible for any inaccuracies, neither for any subsequent loss or damage arising.

Every effort has been made by the publisher to contact holders of copyright to obtain permission to reproduce copyrighted material. However, if any permissions have been inadvertently overlooked, teNeues Publishing Group will be pleased to make the necessary and reasonable arrangements at the first opportunity.

Bibliographic information published by the Deutsche Nationalbibliothek: The Deutsche Nationalbibliothek lists this publication in the Deutsche Nationalbibliografie; detailed bibliographic data are available on the Internet at dnb.dnb.de.

Published by teNeues Publishing Group

teNeues Verlag GmbH
Ohmstraße 8a
86199 Augsburg, Germany

Düsseldorf Office
Waldenburger Straße 13
41564 Kaarst, Germany
e-mail: books@teneues.com

Augsburg/München Office
Ohmstraße 8a
86199 Augsburg, Germany
e-mail: books@teneues.com

Press Department
e-mail: presse@teneues.com

teNeues Publishing Company
350 Seventh Avenue, Suite 1702
New York, NY 10001, USA

www.teneues.com

teNeues Publishing Group
Augsburg/München
Berlin
Düsseldorf
London
New York

teNeues